Τηλουρὸν δὲ γῆν ἥξεις, κελαινὸν φῦλον,
οἳ πρὸς ἡλίου ναίουσι πηγαῖς, ἔνθα ποταμὸς
Αἰθίοψ.

———

Then thou shalt come to the far-off country
Of a Black Race that dwells by the fountains of the sun,
Whence Aethiopia's river.

OCTOBER 2011

Vol. 1 No. 1

CONTENTS

Ears to the Ground . 6

Egie Ighile, One for Alpha's Bet . 8

Editors, *The Crisis*, The Colored Magazine in America 13

Ralph H. Jones, Journalism . 17

Eugene Gordon, Outstanding Negro Newspapers of 1925 . 19

Greg Tate, excerpt from *Coon Bidness* editorial . 25

Editors, *The Crisis*, The Negro in Art . 26

Ryan Inouye and Ethan Swan,
in conversation with Steffani Jemison and Jamal Cyrus . 30

Editors, *The Crisis*, Along the Color Line . 37

Alpha's Bet Is Not Over Yet Artist Contributions . 47

Mitchell S. Jackson, Three Stories . 92

From the Desk of the The Freedwomen's Bureau . 95

Letters . 99

Mattie Hurd Rutledge, *A Hint To Our Women* . 100

Sara Spencer Washington, Beauty . 102

Editors, *The Crisis*, Some Headlines . 103

Advertisements . 104

EARS TO THE GROUND

There are today so many periodicals, and some of them of such excellence, that persons proposing a new venture ought clearly to indicate its object and the need of such enterprise.

Naturally we shall proceed from the point of view and the experience of the black folk where we live and work, to the wider world.

Patriotism has no appeal to us; justice has.

Party has no weight with us; principle has.

Loyalty is meaningless; it depends on what one is loyal to.

Prayer is not one of our remedies; it depends on what one is praying for.

ARE YOU WITH US?

— — — — will be a year of great things. The Country is becoming altruistic and the Negro is emerging from his age of Fire and Blood.

FIRE . . . flaming, burning, searing, and penetrating far beneath the superficial items of the flesh to boil the sluggish blood.

FIRE . . . a cry of conquest in the night, warning those who sleep and revitalizing those who linger in the quiet places dozing.

FIRE . . . melting steel and iron bars, poking livid tongues between stone apertures and burning wooden opposition with a cackling chuckle of contempt.

FIRE . . . weaving vivid, hot designs upon an ebon bordered loom and satisfying pagan thirst for beauty unadorned . . . the flesh is sweet and real . . . the soul an inward flush of fire. . . . Beauty? . . . flesh on fire - on fire in the furnace of life blazing. . . .

"Fy-ah,
Fy-ah, Lawd,

Fy-ah gonna burn ma soul!"

We intend to spread the Eternal Truths of the Creator-endowed equal rights to "life, Liberty, and the pursuit of happiness" of every human being; the ultimate triumph of the forces of moral righteousness over the sordid utilitarianism which influences the powerful to superimpose their rule upon the weak and to subordinate what is morally right to what seems to be practically more expedient.

This we admit is a wide and steep path.

We shall study carefully the trends of the times.

The magazine will be the organ of no clique or party and will avoid personal rancor of all sorts. In the absence of proof to the contrary, it will assume honesty of purpose on the part of all men, North and South, white and black.

Nothing elaborate will mark this publication.

Because of the reality back of it, we continue the use of the older concept of the word "race," referring to the greater groups of human kind which by outer pressure and inner cohesiveness, still form and have long formed a stronger or weaker unity of thought and action.

We use the old word in new containers.

Ears to the ground.

Onward for democracy –

Upward with the race –

Not alms, but opportunity!

THIS IS YOUR FIGHT. !!!!

Sources
The Brown American, Vol I, No I, April 1936
The Crisis, Vol I, No I, November 1910
The Crusader, Vol I, No I, September 1918 and *The Crusader* credo, 1918-1922
Fire !!, Vol I, No I, November 1926
The Messenger, Vol I, No II, November 1917
Opportunity credo, 1923-1949
Phylon, Vol I, No I, March 1940
The Voice of the Negro, Vol I, No I, January 1904

 magazine, as I conceive it, is a mad attempt to map a culture to the contours of one's own mind. Collaged as it is from fragments, it is the maddest synecdoche: I reference this, I reference that; I image this, I image that; and I define a world – define the world, one thinks. Actually, though masterminded it may be, a magazine made manifest is no one mind. It is hive – many minds hived together within what essayist Guy Davenport has called "the geography of the imagination." It is metaphorical making of this space: here a plane of paper – now let your mind fly; here a digital domain – now build you a kingdom: Xanadu for a Kubla Khan.

We stroll through country of *Callaloo*, streets of the *New Yorker,* play the *flaneur* with the *Paris Review;* we stroll these invented worlds, observing their denizens, observing their dress, their manner, their peculiar talk. World mapped for your survey, you move through space filled with wit and grace and the clink of glasses; you move though your body be still, a mass of flesh, bone, and breath softly reclined in a barcalounger somewhere in Chattanooga, Tennessee; or maybe your body modestly

mimics the movement of your mind as you pace a magazine rack (soon to be relic of the past?), gazing at the girls on covers, desiring to possess, desiring to be; "come hither, come," the many colors coo, echoing texts inscribed with voices declaring the pulse of the new; you pass through page after page of worlds ready-made, one with the current, a mind of your *Time . . .* mediated into reality.

While you adjust your pose in the glossy mirror, perhaps we should ask: who has placed these sights before you?

But lest we lose our bearings, first, a bit of taxonomy: a slippery category "magazine," it would seem; publish while counting your pennies, by seat of your pants, your pocket thinned to a four-letter word, then what you make is a "zine;" a "journal" (country of *Callaloo,* and *Transition,* too) tends in this matter to regard itself much more seriously – in fact, I am told institutional funding quite requires a sober face; a "magazine," then, typically described, parades its wares, like a brazen strumpet, right in the thick of the market – etymology of the word tells us as much, deriving from the French *"magasin,"* meaning "warehouse, store, depot;" commerce, we can say, is deep in

its blood, and deeper than that, it could be fairly argued we are consanguine in our commodity culture thanks to this thing, the magazine.

And now a word from our sponsors:

"The Hearst Foundation, founded in 1945 by publisher and philanthropist William Randolph Hearst, is dedicated to ensuring that people of all backgrounds have the opportunity to build healthy, productive and inspiring lives."

"Founded in 1940, the Rockefeller Brothers Fund (not to be confused with the Rockefeller Foundation) advances social change that contributes to a more just, sustainable, and peaceful world."

"The Skadden, Arps Education Programs Fund founded by law firm, Skadden, Arps, Slate, Meagher & Flom furthers creativity and cultural understanding through educational programs that bring the general public in touch with the arts."

"And Goldman Sachs Gives, established in 2007 by banking and securities firm Goldman Sachs, is a donor-advised fund, part of the firm's tradition of individual philanthropy, because here at Goldman Sachs we truly believe in giving back to the world."

And now back to your sponsored content:

We can credit (or blame) Samuel Sidney McClure. On May 28, 1893 his eponymous publication, *McClure's Magazine* debuted on newsstands for fifteen cents a copy. *McClure's* was a monthly digest of fiction featuring the likes of Rudyard Kipling, Stephen Crane, Robert Louis Stevenson, and Conan Doyle; it included intimate-toned, in-depth profiles on historical figures, including Napoleon and Lincoln, and was spiced with elegant photoengravings, all packaged to appeal to a nation's newly emergent middle class – the professional class, managers of America's late nineteenth century industrialization.

Prior to this, magazines had been an affair of the upper classes; and genteel "family house magazines" such as *Atlantic Monthly, Harper's Monthly, Century*, and *Scribner's* cultivated an aesthetic of rich refinement and leisure at a cover price of thirty-five cents or a quarter, which was just enough, it would appear, to make any but the most refined wallets wary.

Sensing shrewd strategy, *McClure's* competition within what was to be the industry of the popular magazine, *Cosmopolitan* and *Munsey's*, dropped their prices, respectively, to twelve and a half and ten cents. It was Munsey's in particular that hit pay dirt. While circulation of none of the genteel magazines had ever exceeded 200,000, by April of 1894 Munsey's had a readership of 500,000 and by 1898 founder Frank Munsey was confident enough to declare his publication the largest in the world. Unlike *McClure's, Munsey's* wasn't known to traffic in literary prestige; pulchritude was more in line with its thing, pictures of glamorous women and high society for aspiring eyes, plus what was hot in the culture game, a formula which, as the numbers tell, gives the folks just what they want.

How was it *Munsey's, Cosmopolitan*, and *McClure's* (and the Ladies' Home Journal, priced for only ten cents) could afford to court a public of the non-genteel? The wonderful world of advertising. Mammoth expansion in readership of monthly magazines – 18 to 64 million from 1890 to 1905 – was catnip to producers of consumer goods who needed increased demand due to a constant specter of over-production. Thus, in addition to celebrity profiles and tales of high romance or Western adventure, readers were introduced to R&G Corsets, Cream of Wheat, Korn-Kinks Cornflakes, Coca-Cola, Kelly-Springfield Tires, Pears' Soap, and Quaker Oats and the list goes on. By a dovetailing of interests between producer and publisher, reader turned consumer. And the paradigm was set for

our ad-revenue driven mass-culture of today. More subtly yet, between editorial and advertorial interplay a national identity began to coalesce – that of the upwardly mobile middle class mind, spiritual heir to the industrial bounty of modernization, an identity premised on progress.

John Brisben Walker, editor and publisher of *Cosmopolitan* (which, incidentally, in 1905 he sold to William Randolph Hearst), regaled his readers with prophecy of the artist-designed, harmoniously-planned city of the future. Along with the other general interest magazines, *Cosmopolitan* celebrated the rise of car and camera, the department store, more efficient criminal identification, and the oncoming era of the "flying machine." And Walker, one to put his money where his mouth was (or maybe the other way round), founded the Locomobile Company of America. Rationality, industry, science, technology. Of modern magazine pioneers, McClure exhibited the most idealistic zeal, disseminating the innovative ideas of educationalist Maria Montessori within his publication's pages. And in November of 1902 he released the first installment of Ida M. Tarbell's investigative essay which popularized what thanks to Teddy Roosevelt came to be known as "muckraking." Tarbell's *History of the Standard Oil Company* was simultaneously an exposé of the unscrupulous means by which John D. Rockefeller had built a modern multinational corporation and an admiring gaze at the efficiency of vertically integrated production that corporation had achieved.

Though *McClure's* early muckrakers announced in its founder's words, "an arraignment of American character," their critiques were framed within a general acceptance of the teleology of American corporatization – a general acceptance shared by the professional-managerial middle class audience who purchased the magazine that carried the critiques. Part of this magazine-imaged, ready-stocked bag of general acceptance was, as one would expect, a non-acceptance of blackness. Non-acceptance, that is, of non-neutralized blackness, since we may assume there was blackness enough in pickaninnies hawking Korn Kinks Corn flakes, Pears' Soap, or Knox's Gelatine. Black discourse, however, was verboten.

This history of the early mass magazine is one detailed by Richard Ohmann in his book "Selling Culture". Its incisive examination of the revolution in magazine publishing at the turn of the century provides context for the era that produced the black periodicals of this exhibition. While "Selling Culture" devotes a section to the marginalization of blackness within early mass magazine white-washed space, primarily, it's an analysis of how birth of the mass magazine consolidated a national self-image constituted by the professional-managerial class. The socio-economic assumptions integral to that image are by now the given terrain of our conceptualizations, the given terrain of our acts. We are ambiguous beneficiaries of a consumerist cornucopia of commodities, witnesses to the conjuring power of capital, and everything our culture produces and every act of cultural production has to navigate its relation to this.

In experiencing the magazine or journal or zine as creation of imaginative space, social space, space for possible questions and re-conceptualizations, what one also experiences, by the nature of the form, is an expression of a relation to capital.

A

A periodical is a commodity, requiring capital to produce. How that capital is sustained, be it through advertiser, deep-pocketed reader, private benefactor, institutional sponsor, or one's own purse, carries implications for the way the voice of a given publication generates or fails to generate conversational air, how it resonates with the existing air, and carries implications for the reach and texture of that voice. It even influences how we taxonomize that voice: magazine, journal, zine. Of the "independent" voice the question becomes: Independent in what way and independent of what?

Chandler Owen and A. Philip Randolph, in 1917, started *The Messenger* as a socialist rallying cry for black America. It was sold at fifteen cents a copy because like every commodity it had to compete in the marketplace not just of ideas, but of goods. However, at that price the magazine wasn't able to be self-sustaining. It was heavily subsidized by donations from Jewish socialist publishers of the *Daily Forward* and a $10,000 grant from the Garland Fund. And the Fund itself had been established by a Wall Street stockbroker's son who decided to turn his inherited wealth against the system by which it had been acquired. And the grant was secured for *The Messenger* thanks to the help of James Weldon Johnson of the NAACP. But the NAACP also represented a strand of black political thought – reformist, assimilationist – from which *The Messenger* distanced itself.

The Messenger was often engaged in a battle of polemics with the NAACP's own magazine, *The Crisis*, founded by W.E.B. DuBois in 1910, who prior to his call for black support of WWI had been the intellectual idol of Randolph. *The Crisis* spoke with the voice of the Talented Tenth, DuBois's conception of the educated, middle class, black elite. Flip through its pages and, in its mix of fiction, profiles, news, and editorials, one finds evidence of the group's urbane sensibility and economic aspirations. There are ads for black universities, books by black authors, a variety of goods befitting comfortable living, and solicitations from the cream-of-the-crop of a partially independent black economy: taxicab companies, hotels, insurance, banks, construction – for this was a time – before the calamity of the Great Depression – that experienced a boom in the building of black enterprise. In fact, the crisis leading Du Bois to depart from *The Crisis* and the NAACP in 1934 was his published articles advocating for the black community a more thoroughly independent economy, organizing producer and consumer cooperatives, as a response to worsening conditions of the 30s. These conditions – a result of capital's societal immolation – had led him to reconsider the very nature of America's economic ideals.

With its radical critique of the existing economic order, calls for interracial labor organization, and its First World War anti-war stance, *The Messenger* was infamously declared by the Department of Justice "the most dangerous of all the Negro publications." The government, stoked by Red Scare fear of an American Bolshevik revolution, in 1919 launched aggressive measures to silence radical activists – the makers of *The Messenger* among them. This mood of hysteria, fed by the mainstream press, led to increased circulation for radical publications, and *The Messenger* saw readership rise from 15,000 to between 21,000 and 33,000 between summer and fall of that year. But by the mid 20s, violent government suppression

of a key ally, Industrial Workers of the World; and economic impoverishment of a central symbol, Russia's new Bolshevik state – brought on by the Pyrrhic victory of its civil war; and the counter-revolutionary wave that swept through Europe; had served to erode the magazine's revolutionary zeal. Social reformism became its credo, and, with its socialist benefactors falling away, *The Messenger* began to resemble *The Crisis* – ads, content, and all. It was at that time it became known for its literary offerings.

As contributing editor to *The Messenger*, among those Wallace Thurman introduced to its pages were Arna Bontemps, Langston Hughes, and Zora Neal Hurston. Along with other members of what he dubbed the Harlem "Niggerati," Thurman, desiring art free from the burden of political self-presentation and middle class mores, struck out to produce the periodical where sly Niggerati could let it all hang loose: *Fire!!* At least, a periodical was the plan. Apparently a bit too loose for the proper literati who deigned to read it, *Fire!!*, though it lives in our geography of the imagination as singular destination, as commodity was abject failure – a periodical absent periodicity – whose remaindered copies of its single issue met their end in a fire. The very quality for which *Fire!!*, now an acknowledged classic, failed in its time – the inability to present an image for which there was market – reflects ramifications of the complex counterpoint of magazine as art, magazine as map, and magazine as commerce. Culture by definition is mediated reality; and of the world's inscrutable territory, we fashion a map: a magazine of words and images, our sensations shaped into meanings, representations of human experience; we observe the abstract figures, adjust our pose in the page's mirror, and so it goes on . . .

THE POWER OF KNOWLEDGE

"KNOWLEDGE SHALL FOREVER LEAD IGNOR-ANCE, AND THOSE WHO WOULD BE OUR LEADERS MUST ARM THEMSELVES WITH THE POWER THAT KNOWLEDGE GIVES."

JAMES MADISON

A

THE COLORED MAGAZINE IN AMERICA

IN AMERICA

The Crisis, Vol. 5 No. 1 (November 1912)

HE first colored magazine in America seems to have been *The African Methodist Episcopal Church Magazine,* edited by Dr. Hogarth, general book steward, and published in Brooklyn, in October, 1841. This magazine was in a sense the ancestor of THE CRISIS. Its editor seems to have been a native of Haiti, although little is known of his life and work. The prospectus of the magazine says: "In embarking upon this laudable enterprise it becomes our duty, in the onset, to inform our friends that such a work cannot be concluded with dignity and honor to our people unless it meets with ample supply of pecuniary and intellectual means. A fear of failure in obtaining these important contingencies had, in a great measure, prevented our brethren in their deliberations from coming to any conclusions on this important subject. But, judging from the present aspect of things, that the times have greatly changed in our favor as a people, light has burst forth upon us, intelligence in a great measure is taking the place of ignorance, especially among the younger portions of our people, opening the avenues to proper Christian feeling and benevolence—our brethren, from those important considerations, came to the conclusion, at our last New York annual conference, held in June, in the city of Brooklyn, to order such a work and lay it before the public for their patronage." This magazine lasted two or three years. Its publication was then stopped.

After an interval of forty years Bishop B. T. Tanner began the publication of the *A. M. E. Church Review Quarterly.* This has been published as a quarterly magazine from 1885 down to to-day and is now receiving new life from its recently elected editor, Dr. R. C. Ransom. The first number of the *Review* says editorially: "My church, the African Methodist Episcopal, at its recent quadrennial session in Baltimore, concluded to have not only a weekly paper, but a *Review,* for the present quarterly, but intended to be bi-monthly, with the management of which it honored me. I have, therefore, gentlemen, to ask at your hands the same friendly consideration you so generously accorded me when editor of the *Christian Recorder.* Grant an exchange. Speak a word—when merited. What we present is unique in the world of letters. If you think so, advise the thoughtful of your readers to subscribe for it."

A quarterly magazine, however, did not quite fill the bill, and in the years from 1845 to the present there have been a number of other adventures. There was, for instance, *The Repository of Religion and Literature,* published in Indianapolis and afterward in Baltimore for several years. In later days the *Colored American Magazine,* started by a colored man who put the savings of his life from days' labor into it, was first issued in Boston in 1900, and rapidly attained a wide circulation. At its zenith it distributed 15,000 copies. Then, however, its troubles began. It was at one time sold for debt, but Colonel William H. Dupree rescued it, and it seemed about to take on new life when further difficulties occurred. It was suggested to the editor, who was then Miss Pauline Hopkins, that her attitude was not conciliatory enough. As a white friend said: "If you are going to take up the wrongs of your race then you must depend for support absolutely upon your race. For the colored man to-day to attempt to stand up to fight would be like a canary bird facing a bulldog, and an angry one at that." The final result was that the magazine was bought by friends favorable to the conciliatory attitude, and transferred to New York, where it became so conciliatory, innocuous and uninteresting that it died a peaceful death almost unnoticed by the public.

Meantime, a firm of subscription-book printers, then known as the J. L. Nichols Company, conceived an idea suggested to it by one of its agents of publishing a colored magazine in the South. *The Voice of the Negro* appeared in January, 1904, and a young man then just out of college, Mr. J. Max Barber, was made its editor. *The Voice of the Negro* proved the greatest magazine which the colored people had had. It reached a circulation of 15,000, and at one time

printed 17,000 copies. It was a magazine of fifty-five pages of reading matter, was illustrated and well edited. The whole story of its final failure has not been written, and perhaps ought not to be for some years to come. Suffice it to say that the fault did not lie with Mr. Barber. The editorial work was well done. The business side, on the other hand, under a succession of men, was not as well attended to; nevertheless, it was not a failure, and the magazine might still be alive had it not been for sinister influences within and without the race that wished either to control or kill it; and finally, had it not been for the Atlanta riot. Mr. Barber found himself continually hampered by interests which were determined to edit his magazine for him. When he asserted his independence these interests appealed to the firm which was backing him and finally so impressed them that they determined to unload the proposition on a new corporation. Stock in the corporation sold slowly, but it was beginning to sell when the instigators of the Atlanta riot drove Mr. Barber from the city. Removing to Chicago, Mr. Barber

found himself facing the task of re-establishing his magazine with practically no capital. He made a brave effort, but finally had to give up and *The Voice of the Negro* ceased publication. Its successor is THE CRISIS, and it looks as though this latest candidate for popular favor was going to be permanently successful.

Since then THE CRISIS represents so interesting a series of magazines, perhaps a word should be said for its force and dwelling place. As one rides down Broadway, New York, past the tallest building in the world, one comes to the old postoffice on City Hall Park and Park Row, the center of newspaperdom. Vesey Street is the westward extension of Park Row across Broadway. There, opposite the moss-grown graves of St. Paul's churchyard, rises a brownstone building of the older office design. You come up a long flight of stairs and enter our rooms.

The big library and workroom greets you first. From this you pass by the agents and subscription clerks to the two editorial offices or to the offices of the secretary of

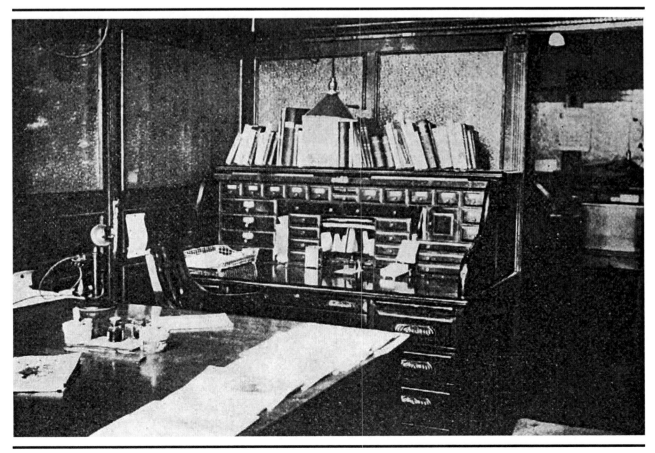

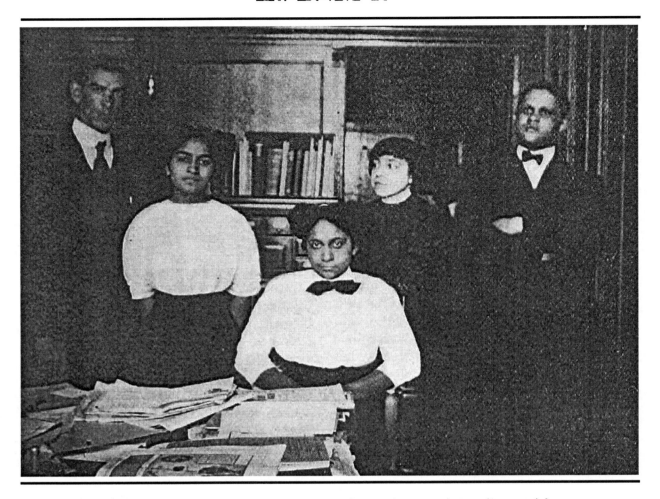

the National Association for the Advancement of Colored People and her assistant. Turning the other way you find the cashier in his den and the advertising man, and finally the store and mailing room with their periodicals and machine. The present force of THE CRISIS consists of an editor, three clerks, a bookkeeper and advertising man, four unpaid editorial assistants and 489 agents in the field.

Many persons do not understand the relation of THE CRISIS to the National Association for the Advancement of Colored People. The association owns and publishes THE CRISIS

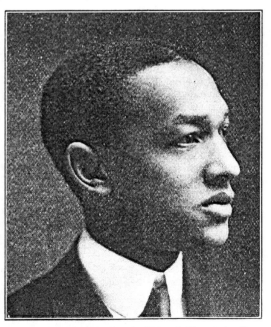

GEORGE WESLEY BLOUNT, of Hampton, Va.
The First Subscriber to THE CRISIS

and uses the magazine as its especial organ of publicity. At the same time it aims to make THE CRISIS more than a mere bulletin of its work, and to conduct it as a magazine of general information in its sphere. The two institutions make, therefore, parts of one great whole.

To no part of its force does THE CRISIS owe more than to its little army of agents scattered over the world. They sell every month from six to 1,400 copies each. Finally, we cannot forget, and would not have our readers forget, our first paid-up subscriber: Geo. W. Blount, of Hampton Institute, Virginia.

A

JOURNALISM

Brown American, Vol. 1 No. 1 (April 1936)

JOURNALISM for Negroes is just enjoying its infancy, relatively speaking. In spite of the fact that it dates back to the days of slavery, Negro journals are just beginning to measure up to what a newspaper should be—an informative, entertaining and necessary part of the social order.

Negro journals, if monthly and quarterly publications may be so classed, had their inception as a distinctly class affair. They were instituted by well-wishing Abolitionists as propaganda media. In truth, Negroes themselves did not publish these journals, for funds and editorial ideas were supplied by white capitalists who had conscientious objections to the slavery idea. After the pioneer journals and from this group ultimately evolved the present-day newspapers and some few magazines.

The first known recorded Negro publication was the "Freedman's Journal," which began publication March 30, 1827, in the State of New York. It was closely followed by another, "The Rights of All," published in the same State on March 28, 1828. Both of these journals were anti-slavery organs. They both had a sort of erratic publication, but somehow managed to stumble through the years.

New York seemed to lend itself to the establishment of this type of publication for, in January, 1837, the first Negro Weekly motivated by the same impulse was instituted. This weekly magazine remained in existence for three months, at which time it gave birth to "The Colored American." Philadelphia contributed its first Negro journal to the world with the publication of "The National Reformer" in September, 1838.

The first church publication was released in September, 1841. "The African Methodist Episcopal Magazine" was its name and the place of publication was Albany, New York. Other pioneer journals and the date and place of their publication are as follows: "The Elevator," Philadelphia, 1842; "The People's Press," New York, 1843; "The National Watchman," Troy, New York, 1842; "The Clarion," Troy, New York, 1842, and "The Northern Star," Philadelphia, 1843, which later changed to "The Mystery Star" the same year. This latter was published in Pittsburgh.

"Genius of Freedom" came in 1845; "Rams Horn," New York, 1847; "The North Star," Rochester, New York, 1847; "The Imperial Citizen," Boston, 1848; "The Christian Herald," Philadelphia, 1848; "Colored Man's Journal," New York, 1851; "Alienated American," Cleveland, 1852.

"Palladium of Liberty," Columbus, Ohio, 1852; "Disfranchised American," Cincinnati, 1852; which later the same year changed to the "Colored Citizen"; "The Christian Recorder" became the new name of "The Christian Herald" in 1852 (this publication is still in existence); "Mirror of Times," San Francisco, 1855; "Herald of Freedom," 1855, and "The Anglo-African," published in New York beginning July 23, 1859.

Of all the above publications the "Christian Recorder" is the only one now published that was established prior to 1865.

In 1863 there were only two newspapers in the United States that were published by Negroes. The first published was "The Colored American." It was initialed in Augusta, Ga., in October, 1865. J. T. Shuftin was the editor.

At the present time there are about 250 Negro papers and periodicals. Of this number there are 17 monthlies and bi-monthlies and quarterlies. There are also fifteen different Negro publications in the British West Indies, some of which have enjoyed a steady, healthful growth.

Many of the true Negro newspapers are either weekly or bi-weekly publications. There have been numerous attempts at daily publications, but the competition of white dailies has proved to be too costly. The latest attempt at daily publication was undertaken by a paper in Atlanta, Georgia.

What has retarded the growth of Negro newspapers?

The main hold-back has been that the papers were either owned by individuals who used the organ for personal gain or else a family so dominated their control that modern journalistic methods were ignored. The major publications of today have something of that characteristic, with one possible exception. This exception is the great weekly journal—"The Pittsburgh Courier." Others, such as the "Baltimore Afro-American," "The Norfolk Journal and Guide," "The Chicago Defender," "The Philadelphia Tribune" and several others are family owned.

"The Philadelphia Tribune" is possibly the oldest of this group. Its founder, Christopher Perry, found it politically advantageous, a fact for which he is not to be censured. He dominated the field of his publication for over twenty-five years without competition. At the present time every major post is held by an offspring or relative of the founder. This same is true of the "Afro-American," with the possible exception that the Murphy family has such a large institution that many of their paying jobs have been spread out.

In point of circulation and national character the "Pittsburgh Courier" is the largest current newspaper of Negroes. Its weekly publication exceeds 108,000 and can be found in practically every portion of the country. The "Chicago Defender" rates probably second in this respect, having a circulation of slightly over 85,000 weekly. The "Afro-American" rates third. A few years ago the "Chicago Defender" topped the journalistic field throughout the country. At one time its circulation was reputed to be well in excess of 150,000 weekly. The "Philadelphia Independent," a five-year-old tabloid, is perhaps the youngest example of pioneering, for this publication has enjoyed a creditable growth in a short span.

Owners of Negro journals are now beginning to realize that their publications are being compared with the daily papers being released and if they fail to measure up, not only does circulation fall off, but that advertising, the backbone of any newspaper, takes a death-palling slump.

RALPH H. JONES.

OUTSTANDING
NEGRO NEWSPAPERS OF 1925

Opportunity, Vol. 3 No. 36 (December 1925)

By Eugene Gordon

AN analytical survey of Negro newspapers in the United States disclosed for 1925 many interesting facts. One was that although general underlying principles upon which each of these papers is built remained constant thruout the year, their contributory principles fluctuated like mercury in a thermometer: in one issue they reached a high level of excellence and in another descended to a state approaching mediocrity.

Another fact disclosed was that no Negro newspaper, apparently, has any permanent system, rigid or elastic, of general make-up—arrangement systematically of all editorial material. This was most forcibly impressed upon me following my discovery in the "green edition" of the Baltimore *Afro-American* of February 21 of an almost perfectly made up first page. Read from my note-book: "Make-up of page one is inclined toward systematic proportioning. Best seen so far; closely resembles almost perfect make-up of New York *Times*. Too bad the scheme is not followed on inside pages."

Not only was the *Afro-American* watched after that for another nearly perfect first page (I soon learned that it was a waste of time to look for such orderliness in other pages), but each of the scores of other papers, as well, was watched. The *Afro-American* has a number of times approximated that excellent first page, but never again equalled it; few other papers, as far as I know, have consistently approximated it. The Savannah *Tribune* seems to come nearer than any other to following a definite scheme of make-up, week after week. Whether it is accidental or calculated, its editor alone, perhaps, knows.

II

For the purpose of this survey there has been devised a set of standards similar to that employed last year. Contents of newspapers studied may, according to authorities on the subject, always be grouped in nine classes: (1) news; (2) editorials; (3) special feature articles; (4) dramatic and musical criticisms and book reviews; (5) practical advice and useful information; (6) humorous matter; (7) fiction; (8) illustrations; (9) advertisements. That, in my opinion, is an excellent schedule for the managing editor to take with him as a guide when he goes to the make-up room. But such a classification is unnecessary in a paper of this kind. Those nine classes may be grouped into four, thus: (1) news (includes sports and advertising); (2) editorials (does not include "exchanged" material); (3) features (dramatic and musical criticisms, practical advice and useful information, book reviews, humorous matter, fiction, illustrations—except illustrations accompanying news stories).

Make-up is included. The "good" reporter or the "masterly" feature writer or the genius at writing editorials is no more the artist than the skilled operator of the typesetting machine or the intelligent, careful proofreader. Because, therefore, the so-called mechanical department is as much responsible as the editorial department for final judgment in any critical survey, this department too receives consideration here. Nevertheless, because the matter of make-up is one which interests primarily members of the craft, this will receive the lowest percentage.

III

Various newspapers have various methods of writing news stories. It is almost universally agreed, however, that the best stories bear, among other characteristics, this one: first paragraph states tersely the gist of the story, so that what follows that is merely an expansion.

In this survey the old formula (well known to all newspapermen), embracing the "five W's," is used: Who? What? When? Where? Why (or How?)? That is to say, in the first paragraph of each story the answer was sought for each of these questions: Who was the person involved? What happened? What is the reporter writing about? Was it a murder or a marriage, an earthquake or a fire? What happened? When did all this take place? Was it last night? If so, at what time? Was it this morning? Today, noon? Just when did it happen? And where did it take place, and why or how? What were all the circumstances.

As to editorials: an authority says that "any writer who can analyze for the average reader his mounting tax problems; who can initiate and direct a campaign that will improve the streets of his city; who can make a drive against the slums and dives that infest almost every large community and even some of the most remote country districts; who can aid in the Americanization of its foreign population; who can promote education and the betterment of the public school system; who can improve the health of his town through sanitation, public health, nursing and free clinics; who can advance its religious activities; who can quicken interest in public lectures, plays, art, or literature; who can write to women as well as men, and to youth as well as age—any one who can do even a small percentage of these things can find subjects that will appeal, and he may be assured of success in the editorial-writing department of any paper."

Unfortunately, too many of our editorial writers assume that most of these things are for the attention of the "white" press only. Negro editorial writers as a class are too closely restricted by racial interests; they are not sufficiently concerned with civic, state and national interests.

Intellectual integrity is an important ingredient of an editorial writer's make-up: too many are lacking in this quality. An editorial writer who will "lift" bodily from an exchange something that

A

he likes, and fail to give credit to the exchange, is lacking not only in intellectual integrity but is deficient in intellectual honesty.

Likewise are there too many editorial writers who use their columns for personal assaults on their contemporaries. Readers care nothing for the personal dislikes, petty jealousies and silly prejudices of editorial writers. They regard, and rightly, the newspaper as a public institution and do not like to see it subverted to the use of selfish and vulgar personalities.

An editorial writer should be informed; to be uninformed in a matter calling for editorial attention is sufficient reason for his leaving that matter to someone who knows the subject. One of the most conspicuous examples of ignorance that came to my attention was found in an allegedly interpretive editorial on the Scopes trial. Although supposed to be giving his loyal followers irrefutable facts, that editorial writer asserted time after time that the Darwinian theory "teaches that man is descended from the monkey."

Above all, editorial writers should be able to write correctly the English language. Many of them are not able to do so. Some of them might profitably spend a portion of their time in the study of grammar, rhetoric and composition. Let those who believe I exaggerate consider the following sentence from an editorial of one of the supposedly "best edited" Negro newspapers: "There is no means of him knowing that he did not marry a girl with African blood that flowed through the veins of one of his aristocratic forebears."

In rating editorials the foregoing principles have been kept in mind. Less attention has been given mechanical form, although those editorials in which writers seemed to ignore all principles of technique are, all other essentials considered, classed below those in which technique received consideration.

In the rating of features attention has been given those only which originated in the offices of the papers considered. Features are made to include all matter which is not elsewhere classified as news, editorials or advertisements.

Papers selected as most outstanding include only those which meet the following requirements for what should, in my opinion, constitute the true modern newspaper: (1) more or less all the news more or less well written; (2) intelligent, well written, readable editorials; (3) entertaining or instructive—always pleasing—features; (4) a systematic, balanced scheme of make-up, in which clean, clear-cut type is used and the page is made to represent an attractive appearance.

From the foregoing requirements the following table of measurement was constructed:

News	50%
Editorials	20%
Features	20%
Make-up	10%
	100%

IV

Before applying this table I shall quote directly from the notebook that remained with me throughout the year. These notes were written weekly, and it is impossible for one who reads only a few quotations from them to determine future tendencies in the papers studied. As has been said elsewhere, values fluctuated in each of them from week to week. What was said of the *Afro-American* one week could properly be said of the *Journal and Guide* another week, and so on to the end. Averages, taken at the end of the year, told the final story.

Let us read:

"*Afro-American* (Feb. 21-25):

"News—Apparently all the news of colored peoples. Unique method of presenting first paragraph in larger type (slightly indented) than the remainder of the column. Sometimes this paragraph has the aspect of a plain statement of fact; at other times it savors of the editorial. Statement of fact all right as introduction to story; but editorials would more properly follow, than lead, the story.

"Editorials—Excellent editorial in interpretive vein on closing of Brown and Stevens' bank. Interesting editorial on failure of Maryland courts to send white murderer to gallows. Three in all.

"Features—'Day by Day,' '15 Years Ago,' 'Old Timer,' 'Professor Fudge,' 'Amos Hokum,' 'Watson's Cartoon'—all are very good original features. Also usual syndicate features. 'Unbleaching America' interesting."

"Norfolk *Journal and Guide* (Sat. Mar. 14-25):

"News—Fairly national; well written; does not print all the news.

"Editorials—Rather flat; not forceful.

"Make-up—Somewhat jumbled; seems to be 'sliping.' Editorial page, however, well made up.

"All in all—Issue as a whole is average."

"Philadelphia *Tribune* (Feb. 28, 25):

"News—Not a great deal of news, but such as there is is well written. Much news in form of short personal items.

"Editorials—Commonplace.

"Features—A few syndicated features.

"Make-up—Seems to be some sort of a system in make-up. Type attractive, making paper easily read.

"All in all—Good average weekly."

"Pittsburgh *Courier* (Feb. 21-25):

"News—Excellent news medium; well displayed and newsy theatrical section. Leading story should be on the right, not left, side of page. No local news on page one. Considerable news pertaining especially to women. Practically all local news in form of brief items.

"Editorials—'Lest We Forget' a vapory puff eulogizing Hamilton Fish; commending him for introducing a bill in U. S. House of Rep. to honor Negro soldiers who were brigaded with French. Other two, on local matters, fair.

"Features—Varied and good. 'Thrusts and Darts,' by Schuyler, exceptionally good column.

"Make-up—Unsystematic. Stuff thrown together without apparent effort at organization. Too many 8-column heads."

"Pittsburgh *Courier* (Mar. 14, 1925):
News—Fair amount. More space given to social news display than is true in any other paper. Fairly well written. Poor taste shown in publication of story headed 'Black and Tan Resort Raided'; probably taken word for word from some 'white' newspaper.

"Editorials—Weak and commonplace.

"Features—'Thrusts and Darts' best. 'The Digest' written by a man who evidently is ill-informed on most matters and is super-egotistical.

"Make-up—Jumbled.

"All in all—Good average."

"New York *Amsterdam News* (Feb. 25-25):
"News—Considerable; very well written.

"Editorials—'Where is Mose?', 'Texas Crimes' are both very good. Brief and pointed.

"Features—Commonplace.

"Make-up—Mediocre.

"All in all—Good average newspaper, standing somewhat above others because of editorials."

"New York *Age* (Feb. 28-25):
"News—Fair amount; spoiled by unsystematic arrangement of heads.

"Editorials—'A Dead University' (referring to Fisk) is excellent. 'How to Reach Churchless' very good. Others also above average.

"Features—Mediocre.

"Make-up—Poor."

"Chicago *Defender* (Feb. 21-25):
"News—Excellent; evidently all news is printed. Could improve writing news; too much of personal opinions of reporters but not so much as formerly.

"Editorials—'The Wet Nurse Amendment' seems to have been written to fit the caption: wishy-washy, meaning nothing in particular. Editorials generally weak. Rogers' cartoon as usual is excellent.

"Features—'Onlooker' interesting but not particularly brilliant. 'Lights and Shadows' popular and good. 'Editor's Mail' good. Dr. Williams becomes too intimate at times in his sex chats. 'Defender Junior' excellent for children.

"Make-up—Average; no system. Headlines out of all proportion to stories which follow. Deafeningly blatant.

"All in all—Very good newspaper."

"St. Louis *Argus* (Feb. 27-25):
"News—Considerable news and fairly well written. Much improvement needed in headline writing.

"Editorials—Sentiment often good but editorials ineffective because sentiment weakly expressed.

"Features—Mediocre.

"Make-up—Type is readable. Heads about right as to type used: conservative and dignified in appearance. Heads not well written.

"All in all—Good average newspaper."

"Savannah *Tribune* (Feb. 26-25):
"News—Fair amount, mostly small, personal items from surrounding towns. Largely a local newspaper because of this.

"Editorials—Commonplace.

"Make-up—Excellent.

"All in all—Average newspaper."

In closing my notebook I wish to mention a breach of newspaper ethics which is shamefully common among Negro editors. I refer to the practice of reprinting editorials from exchanges without giving proper credit—or, often, any credit—to the exchange concerned. It is a pernicious practice and ought to be discontinued. No newspaper may retain creditable standing among honorable contemporaries once it has been found guilty of theft of this sort.

Two journals which had been selected for a probable second list were excluded because, in examining their editorial columns, I discovered stolen matter. One of these, long noted because of its (?) splendid editorials, carried one from the New York *Morning World*. It happened that I had read it in the *World*, so recognized it. There was no credit line, nor anything else to indicate that it was not a product of this editor's own brain.

The other paper had reprinted an editorial from an issue of the Boston *Sunday Post*. It was easily recognized because it happened that I myself had written it. Both these papers were excluded.

V.

Newspapers selected as the most outstanding for the past year are listed in the following order:

1. The *Afro-American* (Baltimore, Md.)
2. The *Chicago Defender*.
3. The New York *Amsterdam News*.
4. The *Pittsburgh Courier*.
5. *Norfolk Journal and Guide*.
6. The St. Louis *Argus*.
7. The *Philadelphia Tribune*.
8. The *Savannah Tribune*.
9. The *New York Age*.
10. The *Pittsburgh American*.
11. The *Kansas City Call*.
12. The *Chicago Whip*.

I shall treat each of the foregoing journals in the order listed with respect, first, to news; then, to editorials; next, to features; and, finally, with respect to make-up (or general appearance). In a recapitulation I shall classify each newspaper according to the four chief divisions, namely: News, Editorials, Features, and Make-Up (or General Appearance).

NOTE—*The Negro Year Book lists something like 240—more or less—Negro newspapers in the United States. I find that a considerable number of these are no longer being published. An average of 190 newspapers each week were given consideration. Editors who care to do so may continue my name on their free mailing list, sending their papers to me at 32 Copley Street, Cambridge, Mass.*

Analytical Valuation of Twelve Outstanding Newspapers

Newspaper	Percentage of Excellence Attained	Standard
1. AFRO-AMERICAN		
News	48%	50%
Editorials	15%	20%
Features	17%	20%
Make-up	5%	10%
	85%	100%
2. CHICAGO DEFENDER		
News	49%	50%
Editorials	14%	20%
Features	18%	20%
Make-up	3%	10%
	84%	100%
3 AMSTERDAM NEWS		
News	45%	50%
Editorials	18%	20%
Features	10%	20%
Make-up	4%	10%
	77%	100%
4. PITTSBURGH COURIER		
News	46%	50%
Editorials	12%	20%
Features	15%	20%
Make-up	3%	10%
	76%	100%
5. PHILADELPHIA TRIBUNE		
News	45%	50%
Editorials	9.5%	20%
Features	10%	20%
Make-up	8%	10%
	72.5%	100%
6. NORFOLK JOURNAL AND GUIDE		
News	43%	50%
Editorials	17%	20%
Features	3%	20%
Make-up	6%	10%
	69%	100%

Newspaper	Percentage of Excellence Attained	Standard
7. ST. LOUIS ARGUS		
News	44%	50%
Editorials	6%	20%
Features	6%	20%
Make-up	9%	10%
	65%	100%
8. CHICAGO WHIP		
News	43%	50%
Editorials	10%	20%
Features	6%	20%
Make-up	3%	10%
	52%	100%
9. SAVANNAH TRIBUNE		
News	40%	50%
Editorials	8%	20%
Features	3%	20%
Make-up	9.5%	10%
	62%	100%
10. NEW YORK AGE		
News	38%	50%
Editorials	16%	20%
Features	3%	20%
Make-up	3%	10%
	60%	100%
11. PITTSBURGH AMERICAN		
News	41%	50%
Editorials	10%	20%
Features	2%	20%
Make-up	3%	10%
	56%	100%
12. KANSAS CITY CALL		
News	44%	50%
Editorials	6%	20%
Features	2%	20%
Make-up	3%	10%
	55%	100%

Rated According to News Value

Newspaper	Percentage of Excellence Attained	Standard
First:	Chicago Defender 49%	50%
Second:	Afro-American 48%	"
Third:	Pittsburgh Courier 46%	"
Fourth:	Philadelphia Tribune 45%	"
	Amsterdam News 45%	"
Fifth:	Kansas City Call 44%	"
	St. Louis Argus 44%	"
Sixth:	Journal and Guide 43%	"
	Chicago Whip 43%	"
Seventh:	Pittsburgh American 41%	"
Eighth:	Savannah Tribune 40%	"
Ninth:	New York Age 38%	"

Rated According to Excellence of Features

Newspaper	Percentage of Excellence Attained	Standard
First:	Chicago Defender 18%	20%
Second:	Afro-American 17%	"
Third:	Pittsburgh Courier 15%	"
Fourth:	Amsterdam News 10%	"
	Philadelphia Tribune 10%	"
Fifth:	St. Louis Argus 6%	"
	Chicago Whip 6%	"
Sixth:	Savannah Tribune 3%	"
	New York Age 3%	"
	Norfolk Journal and Guide 3%	"
Seventh:	Pittsburgh American 2%	"
	Kansas City (Mo.) Call 2%	"

Rated According to Value of Editorials

Newspaper	Percentage of Excellence Attained	Standard
First:	Amsterdam News 18%	20%
Second:	Norfolk Journal and Guide 17%	"
Third:	New York Age 16%	"
Fourth:	Afro-American 15%	"
Fifth:	Chicago Defender 14%	"
Sixth:	Pittsburgh Courier 12%	"
Seventh:	Chicago Whip 10%	"
	Pittsburgh American 10%	"
Eighth:	Philadelphia Tribune 9.5%	"
Ninth:	Savannah Tribune 8%	"
Tenth:	St. Louis Argus 6%	"
	Kansas City Call 6%	"

Rated According to Excellence of Make-Up (General Appearance)

Newspaper	Percentage of Excellence Attained	Standard
First:	Savannah Tribune 9.5%	10%
Second:	St. Louis Argus 9%	"
Third:	Philadelphia Tribune 8%	"
Fourth:	Norfolk Journal and Guide 6%	"
Fifth:	Afro-American 5%	"
Sixth:	Amsterdam News 4%	"
Seventh:	Chicago Defender 3%	"
	Chicago Whip 3%	"
	Pittsburgh Courier 3%	"
	Kansas City Call 3%	"
	New York Age 3%	"
	Pittsburgh American 3%	"

On March 11, 2011, Greg Tate and Latasha N. Nevada Diggs launched Coon Bidness, *a magazine which took its title from jazz composer Julian Hemphill's album of the same name. According to the editors, "[t]he magazine hangs out dirty laundry and celebrates a renegade African cosmopolite spirit in a well-woven series of surreal short stories, Facebook threads, poems and scintillating visuals." In other words,* Coon Bidness *builds upon an existing tradition of visionary publishing projects by and for African American writers and readers. The following is an excerpt from Tate's editorial for Issue 1, "The Critical Ass Issue."*

COON BIDNESS EDITORIAL (excerpt)
by Greg Tate

2.

Oh yes. About the name.

Because all of the other goodblack, racially-overdetermined names were taken.

Because we couldn't call it *Upscale, Emerge, Jet, Striver's Row, Bronze Thrills, Black Enterprise* or *Black Tail.*

Because a formal homage to the entrepreneurial genius of the Real Zip Coon godfather George Walker has long been overdue. You think M.J. was gangsta at the entertainment industry negotiating table? Sheet. Read Camille F. Forbes' *Introducing Bert Williams: Burnt Cork, Broadway and the Story of America's First Black Star*, wherein she breaks down how Walker ganked the Shubert Theater for as-equal coin back in the day. Back in the day as in back when dem not even like negroes being seen on the block, let alone the stages of The Great White Way. And then, obviously because We Heart Julius Hemphill.

3.

About the name. Certain to go down in infamy for some. Certain to mock some and inspire awe in others. Certain to prod peals of "hee-hees" and colloquial recognition from a fourth camp. We can't even claim to be originators of this title. *Coon Bidness* is actually the title of a 1975 album by the saxophonist/composer/conceptualist Julius Hemphill. [...] The decision to use Hemphill's minstrel-friendly album title from the '70s for this magazine originates from the reaction LaTasha and I had to reading online several young African American writers lamenting the scant number of negroes being published in other folk's journals. It struck us as the essence of coondiggery and coondodgery—especially coming nearly a century and a half after the appearances of David Walker's self-published Appeal, Martin Delany's abolitionist newspaper *The Mystery* and Frederick Douglass' liberation screed *The North Star*. So dismayed were we in fact by such sucka-soft expressions of impotence (and lack of DIY initiative), that we had no choice but to tag this rag *Coon Bidness* in response. For nothing so elevates and negates "coon bidness" as not waiting for folk outside of the Black community to do what we been knowing how to do for Self. So consider *Coon Bidness* our rallying cry. An invitation for other 21st century, Black creatives with decolonized minds to reboot our radical tradition of self-determination via self-publishing and hard copy. As *CB*'s inaugural edition's most iconic interview subject Miles Davis once said, 'Get up with it.'

the NEGRO in ART

The Crisis, Vol. 31 No. 5 (March 1926)

WE have asked the artists of the world these questions:

1. When the artist, black or white, portrays Negro characters is he under any obligations or limitations as to the sort of character he will portray?

2. Can any author be criticized for painting the worst or the best characters of a group?

3. Can publishers be criticized for refusing to handle novels that portray Negroes of education and accomplishment, on the ground that these characters are no different from white folk and therefore not interesting?

4. What are Negroes to do when they are continually painted at their worst and judged by the public as they are painted?

5. Does the situation of the educated Negro in America with its pathos, humiliation and tragedy call for artistic treatment at least as sincere and sympathetic as "Porgy" received?

6. Is not the continual portrayal of the sordid, foolish and criminal among Negroes convincing the world that this and this alone is really and essentially Negroid, and preventing white artists from knowing any other types and preventing black artists from daring to paint them?

7. Is there not a real danger that young colored writers will be tempted to follow the popular trend in portraying Negro character in the underworld rather than seeking to paint the truth about themselves and their own social class?

Here are some answers. More will follow:

I am fully aware of the reasons why Negroes are sensitive in regard to fiction which attempts to picture the lower strata of the race. The point is that this is an attitude completely inimical to art. It has caused, sometimes quite unconsciously, more than one Negro of my acquaintance to refrain from using valuable material. Thank God, it has not yet harmed Rudolph Fisher! But the other point I raise is just as important. Plenty of colored folk deplore the fact that Fisher has written stories like "Ringtail" and "High Yaller". If a white man had written them he would be called a Negro hater. Now these stories would be just as good if a white man had written them, but the sensitive Negro—and heaven knows he has reason enough to feel sensitive—would see propaganda therein.

You speak of "this side of the Negro's life having been overdone". That is quite true and will doubtless continue to be true for some time, for a very excellent reason. The squalor of Negro life, the vice of Negro life, offer a wealth of novel, exotic, picturesque material to the artist. On the other hand, there is very little difference if any between the life of a wealthy or cultured Negro and that of a white man of the same class. The question is: Are Negro writers going to write about this exotic material while it is still fresh or will they continue to make a free gift of it to white authors who will exploit it until not a drop of vitality remains?

CARL VAN VECHTEN.

(See also Mr. Van Vechten's article in *Vanity Fair, Feb., 1926.)

I

1. The artist is under no obligations or limitations whatsoever. He should be free to depict things exactly as he sees them.

2. No, so long as his portrait is reasonably accurate.

3. I know of no publisher who sets up any such doctrine. The objection is to Negro characters who are really only white men, *i.e.*, Negro characters who are false.

4. The remedy of a Negro novelist is to depict the white man at his worst. Walter White has already done it, and very effectively.

5. This question is simply rhetorical. Who denies the fact?

6. The sound artist pays no attention to bad art. Why should he?

7. If they are bad artists, yes. If they are good, no.

It seems to me that in objecting to such things as the stories of Mr. Cohen the Negro shows a dreadful lack of humor. They are really very amusing. Are they exaggerations? Of course they are. Nevertheless they always keep some sort of contact with the truth. Is it argued that a white man, looking at Negroes, must always see them as Negroes see themselves? Then what is argued is nonsense. If he departs too far from plausibility and probability his own people will cease to read him. They dislike palpable falsifications. Everyone does. But they enjoy caricatures, recognizing them as such.

The remedy of the Negro is not to bellow for justice—that is, not to try to apply scientific criteria to works of art. His remedy is to make works of art that pay off the white man in his own coin. The white man, it seems to me, is extremely ridiculous. He looks ridiculous even to me, a white man myself. To a Negro he must be an hilarious spectacle, indeed. Why isn't that spectacle better described? Let the Negro sculptors spit on their hands! What a chance!

H. L. MENCKEN.

No. 1. If the author's object is the creation of a piece of art I feel that he should not be limited as to the sort of character he portrays. He should attempt that which moves him most deeply.

No. 2. If he is a sincere artist, no.

No. 3. Yes. On the grounds of bad business judgment, if nothing else. I feel that there is a growing public everywhere 'n America for literature dealing sincerely with any aspect of Negro life. The educated and artistic Negro, if presented with skill and insight, will find his public waiting for him when the publishers are willing to take the chance.

No. 4. Educated Negroes are rapidly arriving at a point where they are their own best refutation of this type of portrayal. They should, and doubtless will, soon be producing their own authentic literature.

No. 5. Emphatically yes. The point is that it must be treated *artistically*. It destroys itself as soon as it is made a vehicle for propaganda. If it carries a moral or a lesson they should be subordinated to the *artistic* aim.

6, 7. I cannot say. I think the young colored writer in America need not be afraid to portray any aspect of his racial life. And I may say further that I feel convinced that he alone will produce the ultimate and authentic record of his own people. What I have done in "Porgy" owes what social value it has to its revelation of *my* feeling *toward* my subject. A real subjective literature must spring from the race itself.

DuBose Heyward.

F

In a recent number of Harper's, J. B. Priestley discusses the American novel and describes a snag that has caught many an American writer. Our country contains so much variety in its background that our writers forget that this background is of comparatively little importance and think over-much of local color. They thus create fixed types. But the important thing, Priestley emphasizes, is to note "the immense difference between your neighbors".

With this in mind I can quickly answer a number of your questions. A novel isn't made up of all good or all bad, of all buffoons or all wise men. When a book over-emphasizes one type, whether it be the buffoon, the villain or the heroically good young man, it isn't a true book and will soon be forgotten. What publishers, at least the best, want today is art, not propaganda. They don't want to know what the writer thinks on the Negro question, they want to know about Negroes.

Publishers will take books dealing with the educated Negro if he can be written of without our continually seeing his diploma sticking out of his pocket. Just as soon as the writer can believe that his reader knows there are educated Negroes, and doesn't have to be told that they live in pleasant homes and don't eat with their knives, he can begin seriously to write about them. Surely it is unimportant whether a book deals with the rich or the poor. Porgy and Crown and Bess are great figures in a powerful love story. John is a strong figure in Waldo Frank's "Holiday". So is Bob in Walter White's "Fire in the Flint".

Question six speaks of the "continual portrayal of the sordid, foolish and criminal among Negroes". This has not been true within the past few years. White artists are beginning to see the true Negro and colored writers are beginning to drop their propaganda and are painting reality.

Question seven, the danger of the Negro writer's following the popular trend, is a question every writer has to face. It has nothing to do with color. Are you so poor that you yield to the temptation to copy the trivial success? If you do you'll have plenty of company in this world of cheap popular magazines.

"The Right to Honest Toil
Is One of the First Gifts to Man"

INTERVIEW

STEFFANI JEMISON & JAMAL CYRUS
IN CONVERSATION WITH RYAN INOUYE & ETHAN SWAN
NEW MUSEUM OF CONTEMPORARY ART

AN INTERVIEW WITH STEFFANI JEMISON AND JAMAL CYRUS BY RYAN INOUYE AND ETHAN SWAN, CO-ORGANIZERS OF "MUSEUM AS HUB: STEFFANI JEMISON AND JAMAL CYRUS: ALPHA'S BET IS NOT OVER YET" FOR THE NEW MUSEUM

In their individual and collaborative work, Steffani Jemison and Jamal Cyrus explore approaches to self education, the democratic distribution of knowledge, and language as a means of reimagining conventional structures of power. For Project Row Houses in Houston, they co-organized "Book Club," a think tank and reading group with artists, educators, and life-long learners. Jemison and Cyrus expand upon this project in the Museum as Hub space at the New Museum with the presentation of "Alpha's Bet Is Not Over Yet," an exhibition, reading room, and discussion space inspired by the energy and politics of radical, independent Black periodicals published during the first half of the twentieth century. On the occasion of this presentation in New York, the artists share discussions and experiences that initially informed the project in addition to a number of its practical and pedagogical considerations in dialogue with other texts within these pages.

NEW MUSEUM: This exhibition developed out of the project "Book Club" you both initiated at Project Row Houses in Houston. Could you discuss some of the considerations that inspired the Book Club project in Houston and how it has informed this presentation at the New Museum in New York?

STEFFANI JEMISON: In summer 2010, Jamal contacted me to see if I was interested in pulling together a group to read Koduo Eshun's *More Brilliant than the Sun: Adventures in Sonic Fiction* (1998), and we thought it would be interesting to extend that conversation to other texts. Separately, as an artist-in-residence at Project Row Houses, I had proposed to create a book club focusing on writings by black artists and theorists; this idea dovetailed well with his and we decided to work together to create a reading group emphasizing experimental, non-canonical writing by black authors and theorists. [This developed into]"Book Club" [which] consists of a group of artists and writers in Houston that meets at Project Row Houses. Core members have included Regina Agu, Nathaniel Donnett, Quincy Flowers, Egie Ighile, Ayanna Jolivet McCloud, Lauren Kelley-Oliver, Robert Pruitt, and Michael Kahlil Taylor, along with Jamal and myself.

JAMAL CYRUS: Initially "Book Club" was scheduled to meet every other week from September to November [of 2010]. However, due to its success amongst the participants, the project was extended and ran till May [2011]. When conceiving the idea, we were attempting to develop a think tank in which we would read and discuss the works of Black artists and critics whose writings were not widely distributed, but whose ideas we felt were seeking out new territories of Black thought and expressivity.

SJ: As we began to work together, we found that the group offered an opportunity for us to articulate a set of principles that could guide our activity. Perhaps the most fundamental of these was respect for conversation: polyphony, heterogeneity, difference, and exchange. This didn't mean that the group shared a common set of beliefs or that we came to joint conclusions during our discussions, but that by continuing to meet we all signaled our respect for the lasting private, social, and political benefits of conversation. Our discussions touched upon consistent themes: starting with a reading of Koduo Eshun's discussion of Grandmaster Flash in *More Brilliant than the Sun*, we might consider the inadequacies of contemporary hip hop anthems; this often raised the question of whether Young Jeezy or Soulja Boy were actually as worthless as they seem, and whether perhaps contemporary rappers are just misunderstood by the generation weaned on Nas and Tribe; this in turn might lead some to extol the demonstrably underappreciated gems of Houston hip hop; which might lead others to praise the minor, marginalized, and underappreciated gems of Houston, in music and otherwise; and then at this point, we might discuss the financial challenges faced by artists in Third Ward, and indeed, by the Third Ward community in general; this might shift our attention to the man who is asking passing cars for change at this very moment; from here, we might discuss the possibility of progressive solutions for the lack of a grocery store within a mile radius of Elgin and Dowling; we might consider gentrification and how neighborhoods change; a passing car might remind us of the powerful role of music in defining the soundtrack of a neighborhood, welcoming or alienating newcomers; at which point we might double back to Grandmaster Flash and to Eshun's argument. We were very much driven by a sensitivity to place and context as factors that we necessarily engage in our lives and creative work (at the time, this meant a special interest in the specific histories, legacies, and futures of Houston, Third Ward, Project Row Houses, the intersection of Elgin and Dowling).

JC: Due to its setting, the NYC readings will not be nearly as intimate as the Houston sessions. It seemed to us from the beginning of our discussions— and this was confirmed as the group met—that the success of the group depends on the chemistry of its participants. You have to understand that although Houston is the fourth largest city in the US, its arts community is very small and tight-knit, and this is particularly true of artists of color in the city. For the most part, group participants had history together outside of "Book Club". At first, we thought it might be possible to achieve this type

A

of camaraderie with the NYC group; over time we've begun to understand that maybe this is not possible. But there are small ensembles and there are orchestras, and each has its particular benefits and drawbacks. I look forward to seeing how the NYC group will operate and deal with the material. There are some great minds in the city, and people who can make the types of synthesis that need to occur when dealing with the information covered in the reading material.

NM: Jamal, can you speak a little bit about the pedagogical nature of Otabenga Jones & Associates, an organization in which you are an active member along with Dawolu Jabari Anderson, Kenya Evans, and Robert A. Pruitt? Are there experiences you've had with that artist collective that have helped informed and direct "Alpha's Bet"?

JC: In my opinion there are two main factors that drive our usage of pedagogy. The first is that we felt African American political history was being parceled out in segments which omitted very key and critical periods, and that one of the most natural ways and perhaps disruptive ways was for us to address history was through the creation of pedagogically based projects and materials. The other factor is that there exists in Black political thought a tradition which views learning and pedagogy as the most important tools in achieving individual and group liberation. Frederick Douglass, Mary McLeod Bethune, Clara Muhammad, Malcolm X, and the Wu Tang Clan all share the strong belief that education, and particularly self-education, is of primary importance in the pursuit of freedom. This is the sentiment and creative energy Otabenga Jones tries to tap into. "Alpha's Bet" and some of

Otabenga Jones' projects share a common spirit.

NM: One of the unique aspects of "Alpha's Bet" in the context of pedagogical art practice is the concurrent "Book Club", and the understanding that this project and your research is ongoing. Is presenting this information as in-progress an act of cooperation? Or bravery? Or honesty?

SJ: Information is always "in-progress"— discourse evolves, knowledge shifts, and, most importantly, intellectual priorities change. To suggest that "Alpha's Bet" is "in-progress" is to suggest that it will ultimately reach a kind of resolution or conclusion. This is impossible. Instead, we think that "Alpha's Bet" presents a collection of resources—a series of conversations, a collection of posters in response to an open-ended prompt, an arbitrary selection of historical materials, etc. This particular collection is drawn from infinite possibilities—for reasons that are practical (some periodicals are easier to find than others), social (the show enables us to create dialogue among artists working in very different communities), strategic, personal, aesthetic, and political. To present a project is also to articulate a context in which the project can be understood. If "Alpha's Bet" suggests bravery, cooperation, and honesty, I hope it's clear that we're invoking the spirit of generations of writers, artists, activists, critics, theorists, publishers, and readers whose values are reflected in every aspect of the work.

NM: The centerpiece of this exhibition is a newsstand containing hundreds of issues of independent African American periodicals from the first half of the twentieth century. Structurally,

these magazines resemble their contemporaries, there are cover girls, advertisements, editorials, etc. What made these periodicals independent in their day and what about them remains relevant now?

SJ: In magazine publishing, independence means several different things. Major media and publishing corporations were just beginning to emerge in the early 20th century—the Hearst Corporation consolidated its empire of newspapers and magazines by the 1920s, and smaller publishers like Harper & Brothers published books as well as multiple magazine titles. As an alternative to large-distribution commercial magazines, literary chapbooks and "little magazines" were published independently, often serving as significant outlets for radical cultural and aesthetic ideas. Many of the black periodicals featured in "Alpha's Bet" emerged at the same time as, and were certainly influenced by, the little magazine movement. Like the little magazines, they were forced to find funding, manage printing and operations, etc. without the resources that mainstream periodicals enjoyed. But there were important differences: most independent black periodicals aspired to widespread circulation, to effect real political change, often functioning as the only publications in their fields (black education, research) in a way that little magazines did not. They were sober and political rather than stylish and playful. The stakes were high. Publishing has changed in countless ways since the early 1900s, but the discourse generated by early African American magazines remains fascinating today, not only because many of the issues addressed are still relevant, (for example), what are the political obligations of the

intellectual in a democracy? What critical tools enable us to understand the unique features of black expression?

NM: The exhibition materials propose an anti-nostalgic relationship with the reprinted periodicals, asserting the ongoing relevance for this material. However, there seems to be a note of nostalgia imbued in taking the American Library Association's READ campaign as inspiration for the posters. How do you perceive a relationship between these two parts of the project and their relationship with nostalgia?

SJ: Of course our memories of READ posters are nostalgic—a poster featuring Bill Cosby in his library was prominently displayed in my childhood bathroom, and his paternal gaze was reflected in the mirror every time I brushed my teeth. Ironically, the exhortation to "read" is linked with mere images of books—hardly compelling to a non-reader. In fact, READ posters have always seemed fundamentally misaligned: not only do text and image not match up, but the artificial environments are also unconvincing, I doubt that some of the celebrity endorsers were actually avid readers, and the cheesy word art is the opposite of fresh. I link the campaign with a geeky eighties enthusiasm for the dispersion of graphic design tools (using the ALA's proprietary software, anyone can make these posters in the school computer lab or even at home). The use of local sports teams, politicians, etc. to balance images of media and sports stars has a similarly democratic tone—just as anyone can apparently be a graphic designer, so can anyone be a celebrity. In that sense, the initiative is very much tied to the era in which

it originated. That said, our interest lies in the very active contemporary life of the posters. We're interested in how the interaction between image and text can actually serve as an opportunity to articulate the complications surrounding literacy in this country—literacy as a human right, as a political imperative, and as representative of social and personal failure.

JC: I understand nostalgia as a kind of simple harkening back to a previous time. I feel in our thinking about the show we were trying to get away from such approaches, and that many of the historical movements referenced in this exhibition are very unfinished projects, and so are not easily commodified moments.

NM: "Alpha's Bet" seems in dialogue with recent artist-initiated projects and platforms that explore various approaches to self-education and pedagogy, in addition to the exchange and distribution of knowledge. Are there practices that informed your thinking about this project?

SJ: I am very ambivalent regarding self-education platforms in artist communities that serve to consolidate rather than extend knowledge by encouraging a small group of (often highly educated) people to share their knowledge with one another. I'm also frustrated by the fact that such projects often fail to engage the active discourse of critical pedagogy, and that they are uninterested in the history of learning outside of the classroom. I wish that these projects were ambitious enough to consider the implications of their work for education theory and generous

enough to join a larger conversation. In contrast to these, I'm very inspired in the work of Huong Ngo, an artist who has investigated education theory to inform her own practice as a professor and seeks to build upon existing models for alternative education. "Book Club" was also influenced by the open reading and facilitated conversation model of 16 Beaver, a group that is consistently attentive to the relationship between art, education, and empowerment. For many years, I have followed the work of Shaina Anand, and I am hugely supportive of her collaborative project, pad.ma. From the perspective of display, two projects that Jamal and I considered as we developed "Alpha's Bet" were "I Wish It Were True," a VHS archive by Leslie Hewitt and William Cordova, and the e-flux initiated Martha Rosler Library.

NM: Many of the starting points for this exhibition are emergent dialogues. For example, the arcane/visionary nature of Hamptonese, the mathematic linguistics of Rammellzee, and the mysticism of The Nation of Gods and Earths. Can you describe your path to these dialogues and the process of moving them from the margin to the center of the discussion taking place in the exhibition?

JC: Fugitive uses of the King's English. What amazes me about these particular individuals is how they were able to utilize their approaches to iconography, exegesis, and style to create eruptions of the status quo, and produce identities that were light years ahead of social conventions. For me, this [is] where these seemingly divergent materials join the main themes of the exhibition, and pursue

the idea of the archive as reserve.

SJ: In Book Club, we considered emergent and vernacular knowledge alongside traditional forms; it's not always easy to distinguish between the two. The redundancy and accumulation that define the internal logic of hip hop were central to book club conversations; the expressive language of the black church was another recurring theme. These rich discursive forms have been as important, as major, in our own education as the conventions of history and literary analysis, and we made a conscious decision to respect their significance. We frequently discussed the pervasiveness of "excess" and "lack" as metaphors for the success or failure of black expression—black speech as excessive or as insufficient. "Margin" and "center" are similarly metaphorical terms whose implications have been probed by Derrida and other scholars. By reconsidering these metaphors, I don't mean to neuter the unique creativity or very real oppositional power of "fugitive uses of the King's English" by Hampton and Rammellzee, but rather to acknowledge the complexity of describing a path "from margin to center." When we decided to extend the themes of "Book Club" to present a series of installations or resources, it was inevitable that these would include materials that are considered "conventional," like periodicals, as well as ideas that are considered marginal, like the hermeneutic device that is the Supreme Alphabet.

ALONG
THE COLOR LINE

The Crisis, Vol. 6 No. 1 (May 1913)

EDUCATION.

THE United States Census for 1910 reports that 55 per cent. of the Negro children and 35 per cent. of the whites between the ages of 6 and 20 years were not enrolled in school. In Louisiana 75 per cent. of the Negro children of school age are without instruction and in nine Southern States more than half the colored children do not go to school. For those enrolled the school period is very short, and the *Southwestern Christian Recorder* estimates that "there are more than 2,000,000 public citizens of this country who have not attended school six months."

This condition is due to the fact that the appropriation for colored schools in the South is so small as compared with that for whites. In Central Alabama, with a school population equally divided between the races, Mrs. Wooley, of the Douglass Center in Chicago, finds that the whites have school property valued at $6,149,413 as compared with $533,033 for Negroes.

"In the case of Kowaliga community school, for instance," says Mrs. Wooley, "the Negro children practically would get no schooling at all if it were not that William Benson has built up a school with funds sent from New York, Philadelphia and Boston. The appropriation by the county is $60 a year."

¶ William J. Bryan and Mrs. Bryan have given $500 to the Williams Industrial College, at Little Rock, Ark.

¶ The Japanese of Seattle, Wash., have given a scholarship at Tuskegee Institute.

¶ The principal building at Claflin University, Orangeburg, S. C., has been destroyed by fire.

¶ Charles Francis Adams, of Massachusetts, has offered to colored students, "juniors and seniors in attendance at some American college," a prize of $50 for the best essay on "The Effect of Emancipation Upon the Physical Condition of the Afro-American." Those intending to compete for the prize should send their names to Professor Kelly Miller, Howard University, Washington, D. C.

¶ Congress has appropriated $300,000 for Indian schools, but some anxiety is felt in Washington about the delay in the appropriation for Howard University.

¶ Dr. Wallace Buttrick, secretary of the General Education Board, has been conferring with Governor Goldsborough in regard to aid from the fund for Negro agricultural schools in Maryland.

¶ Miss Ellen McKendry, of Houghton, Mass., has bequeathed $2,500 to Tuskegee Institute.

¶ In an address on race culture before the Arundell Club, of Baltimore, Md., Mrs. Anna Beecher Scoville, a granddaughter of Henry Ward Beecher, complained of the tardiness of the trustees of the John Hopkins Estate in carrying out the provisions of the will of the philanthropist with regard to asylums for colored children.

¶ A correspondent of the Baltimore *News* points out that "the colored citizens of Baltimore have improved 100 per cent. since

1

the establishment of the local colored high school. This includes a decrease in criminals, in increase in property holders and perhaps, above all, an increase along moral and religious lines."

SOCIAL UPLIFT.

AT last the emancipation proclamation commission of Pennsylvania has given the public an authentic report of its work.

Of the $20,000 appropriated by the State about $6,000 has been spent in salaries, $600 for rent, and something over $2,000 for general expenses, leaving over $10,000 on hand. The plan outlined for the exhibit contemplates a main building about 84x150 feet, with dining room and auditorium, an agricultural building and a concert and lecture hall. The exhibit will be in three parts —industrial, educational and religious. The industrial exhibit will include farm products, manufacturing, domestic art, the business and professions. Under education will come photographs, singing and an educational congress. Under religion will come photographs and other exhibits. There will also be an art exhibit, a collection of 6,000 volumes of Negro authors and a pageant. Several prizes are being offered, and the commission recommends an additional appropriation of $50,000 by the legislature.

¶ The Negro Organization Society, of Virginia co-operated with the State health department for a cleaning-up day among the Negroes on April 14. The health department has issued a "Health Handbook for Colored People." The board of aldermen of Richmond has instructed the local health department to make an investigation of the housing and sanitary conditions in the Ghetto and to make a report recommending legislation looking toward the betterment of sewerage, water, street and other conditions. The city engineer of Richmond has been instructed to prepare maps and estimates for a proposed park for Negroes.

¶ The location of the colored branch library in New Orleans is still in doubt, as some white people have protested against the site first chosen, although it is in a largely colored neighborhood.

¶ There is a movement on foot to establish a State orphanage for Negroes in Texas.

¶ The Sojourner Truth Industrial Home for Young Women is now nearing completion in Los Angeles, Cal.

¶ The Climbers, a colored women teachers' club in Birmingham, Ala., has given a bazaar to help remove the $3,000 mortgage on the Home for Aged and Destitute Negroes in that city.

¶ In Kansas City $139,963 of a required $225,000 has been raised for a Helping Hand Institute, Negro Y. M. C. A. and Street Boys' Home.

¶ George B. Yandes, a white man, has bequeathed $5,000 to the Negro Y. M. C. A. of Indianapolis.

¶ At the spring dual meet held at Ocean City, N. J., between Ocean City High School and Southern Manual, of Philadelphia, Roland N. Elsey won for the latter sixteen points, that being the highest number of points won by any contestant. He was awarded first prize for the 220 and 75-yard dashes and the mile relay, where he was placed last. Elsey is a colored youth and trainers speak highly of him.

¶ Congress has appointed a commission of three—General J. Warren Keifer, of Springfield, O., chairman; General Nelson A. Miles and an admiral of the navy—and appropriated $300,000 to assist in the celebration of the battle of Lake Erie. Ohio and other States and civic bodies have swelled the total to about $1,500,000. There will be many events in many places, but the celebration will culminate at or near Sandusky, September 10, the anniversary of the battle. Negro sailors took a prominent part in the battle.

¶ All the mail carriers of Helena, Ark., are colored. Recently twenty-two men took the examination for civil service and the two colored candidates were the only ones that passed.

¶ THE CRISIS was mistaken in stating that the acting governor of Jamaica is colored. The Hon. Philip Cork is a white man.

¶ A colored physician of Talladega, Ala., diagnosed a disease which broke out there to be smallpox. The white physicians of both city and State declared it was not smallpox. Eventually it was proven that the colored physician was right.

¶ A bill to create a Negro regiment in the National Guard has been passed by the Pennsylvania legislature.

¶ The colored women and societies of Indianapolis have played their part in

relieving the distress in the wake of the storm and flood in that city.

¶ At Lawrence, Kan., the seat of the State University, the Rev. J. M. Brown, the colored pastor of St. Luke's A. M. E. Church, was toastmaster at a farewell banquet in honor of the Rev. J. N. Brush, the minister of the white Presbyterian church.

¶ Miss S. B. Breckinridge, of Chicago, says in the *Survey:*

"The segregated black district is almost invariably the region in which vice is tolerated by the police. That is, the segregation of the Negro quarter is only a segregation from respectable white people. The disreputable white element is forced upon him.

"In no part of Chicago was there found a whole neighborhood so conspicuously dilapidated as the black belt on the south side.

¶ The Arkansas legislature has made it a misdemeanor to accept a tip and subjects the employer who permits the employee to receive a gratuity to a fine. This act is aimed at Negro waiters.

¶ Fifty per cent. of the 10,000 Negroes in Meridian, Miss., are said to own their own homes.

¶ In Uniontown, Ala., with a total population of 2,000, it is reported that Negroes control about half of the business enterprises. They have $70,000 on deposit in the local banks. Eldridge Brothers, a grocery firm, do an annual business of $40,000 a year.

¶ At Pine Bluff, Ark., an insurance company with a capital stock of $250,000 has been organized. At the initial meeting of the society $5,200 in cash and securities was paid up.

ONE OF MR. DUPRE'S MILK WAGONS.

Not only does the Negro suffer from this extreme dilapidation, but he pays a heavy cost in the form of high rent. In crowded emigrant neighborhoods in different parts of the city the medium rental for the prevailing four-room apartment was between $8 and $8.50; in South Chicago, near the steel mills, it was between $9 and $9.50, and in the Jewish quarter between $10 and $10.50 was charged. But in the great black belt of the south side the sum exacted was between $12 and $12.50."

¶ Six years ago Oscar Dupre, a colored man with a family of six children living in New Orleans, could scarcely make a living doing odd jobs. He decided to try dairy farming. He rented a plantation in Jefferson Parish on the outskirts of the city and bought a few cows on time. To-day he owns 98 milch cows, 6 fine horses and mules, 4 milk wagons, a feed wagon, carriage and a buggy. He sells between 125 and 140 gallons of milk a day, at 30 cents a gallon, supplying the wealthiest families and

physicians, who want specially good milk. He spends $650 a month for feed alone, employs nine persons and has refused $8,000 for his plant.

At Austin, Tex., the Rev. L. L. Campbell and Dr. W. H. Crawford have organized the Texas Colonization and Development Company. They have purchased 10,000 acres of land in Houston County and are selling lots of ten, twenty, fifty and one hundred acres to Negroes only.

At a recent conference in Washington, D. C., the National Benefit Association reported receipts amounting to $146,709 and disbursements of $121,654 during 1912. The resources of the association amount to $133,155.

A recent investigation discloses the fact that 86.59 per cent. of the colored workers in Philadelphia, in industries employing at least 100 colored persons receive an average annual wage of less than $400 a year, while the highest-paid group receive less than $800. The average annual income necessary to support a family of five in Philadelphia is estimated at $750.

Colored waitresses have been dismissed from the service of the Oriental Tea Company in Boston.

Mr. Richard E. Westbrooks, president of the Men's Civic Club of Chicago, has appealed to the vice-investigating commissioners not to overlook the condition of the colored women. He calls attention to the "low economic condition of the colored women and the small wages which they receive in domestic service and the small business firms." In addition to this, "thousands of them are excluded from earning an honest living in many of the great industries of the State on account of race and color. If the low wage is a menace to the white women in the industries, the lack of an opportunity to earn any wage at all is a still greater menace to general moral conditions in Illinois. The moral condition of the white women of Illinois is inseparable from the moral condition of the colored women, and the morals of the white women are not safe so long as conditions exist which prey upon the morals of the colored women. Any attempt to solve the one without the other is little more than scratching the social evil upon the surface."

Mr. Thomas Walsh, superintendent of the New York Society for the Prevention of Cruelty to Children, declares: "It is futile to take the case of a young colored girl to the children's court at this time, owing to a lack of provision for delinquent colored girls in any existing institution." Women's clubs in New York City are raising funds for the establishment of a home for delinquent colored girls.

ECONOMICS.

A COTTON factory in Savannah, Ga., finds Negro women such reliable and satisfactory operators that the proprietor intends to double the present number of 200 employees.

The Afro-American Stock Trading Company has been organized at Louisville, Ky. The company starts with a grocery, but intends later to open a department store. J. W. Buchanan is president of the corporation.

Negro farmers have organized a corn club at Spartansburg, S. C. The purpose of the club is to stimulate intensive cultivation by offering prizes to the highest producer of corn and cotton.

The Mechanical Investment Company, a Negro bank, has been organized at Savannah, Ga.

In Wake County, N. C., Negroes pay taxes on property valued at $1,330,705 and in Halifax County on $1,225,576. In each of fifty-one counties the value of Negro property is more than $250,000.

Negro farmers of Fairhope, Ala., have formed a co-operative packing association.

The United Brothers of Friendship of Texas report total receipts of $42,735 during the last three months. They own property worth $200,000 in two cities, which brings in a revenue of $800 a month.

Sunset Lodge of Colored Masons, in El Paso, Tex., has just completed its three-story brick temple costing $11,000.

POLITICS.

MR. WILLIAM H. LEWIS has resigned the office of Assistant Attorney-General of the United States, and on recommendation of Attorney-General McReynolds, President Wilson has abolished the office which Mr. Lewis held—that of handling Indian claims, as the work is said to have been completed.

¶ Vardaman is on the warpath in Washington. He told newspaper men that he was going to have the Fifteenth Amendment repealed and, generally, "to carry the war into Africa." He is only waiting till Congress disposes of the tariff to fire the first shot.

¶ By a vote of seventy to forty-six the lower house of South Carolina has petitioned Congress to repeal the Fifteenth Amendment. The petition alleges that in exchange for the franchise the Negro has given the white people of this country only "anxiety, strife, bloodshed and the hookworm."

¶ The Washington *Post* is authority for the statement: "None of the Federal offices in the South, positions which the Republican Presidents have been wont to confer upon Negroes, will be turned over to them so long as the present administration remains in office."

¶ The colored voters of St. Louis have supported H. W. Kiel for mayor on the Republican ticket. Some of the white labor unions have opposed Kiel because he gave employment to Negroes in a building contract. Tom Hale, formerly business agent of Union No. 1, and a Socialist, declares that he will "throw his vote away on the Democratic candidate rather than vote for a man who would not consent to employ white labor exclusively."

¶ The resignation of Mr. Fred. Moore, United States Minister to Liberia, has been asked and accepted. Moore served an uneventful term of twenty-nine days.

MEETINGS.

MEMORIAL meetings have been held in honor of David Livingstone and Harriet Tubman. Speaking at the Charles Street A. M. E. Church in Boston, Mr. Frank B. Sanborn, the biographer of John Brown, said:

"The question of races, of race seclusion and race fusion, of superior and inferior is one which many half-enlightened people are eager to discuss, but one which puzzles the student of the history of man. * * * The American has been so essentially modified by fusion that ideal purity of stock here is nowhere to be found.

"The heroine whose memory we assemble to recall was nearer the mixed type of a great and widely extended race—the West African Negro—than most of us could say of ourselves. She illustrated by her character what I expect will be the future type of that race, when preserved from slavery and degeneracy by a higher civilization than has as yet taken the native African."

¶ Negroes of New Orleans have organized an association to conduct a State fair in honor of the semi-centenary of the emancipation. The association's headquarters are in the Y. M. C. A. building, 2220 Dryades Street. Rev. W. Scott Chinn is the president of the organization.

¶ The semi-annual executive meeting of the Afro-American Press Association was held recently in Philadelphia, Pa. The report of chairman N. B. Dodson showed a membership of 300, representing 250 periodicals controlled by Negroes. The annual general assembly of the association takes place in Philadelphia next August.

¶ Farmers' conventions, conferences of business leagues and teachers' conventions have been held in Alabama, Texas, Tennessee and elsewhere in the South.

¶ Mrs. Mary Church Terrell recently addressed the students of Wellesley College on the subject of opportunities, or rather the lack of opportunities, for colored girls. Miss Mary Eliza Clark, president of the Christian Association of Wellesley, writes as follows of this occasion:

"I do not know when a speaker has aroused so much interest and changed so many ideas in so short a time. I want you to feel that your visit here was distinctly worth while, and that Wellesley people of broadest minds and widest sympathies feel a distinct debt of gratitude to you for the strong presentation of your subject."

¶ At a meeting of the Society for Co-operation of Charities at Albany, N. Y., the Rev. A. B. Morton, pastor of the A. M. E. Church, said that of the 2,000 Negroes in that city, only 200 or 300 attend church, and that there are colonies of neglected people living in such moral and physical degradation as the city would not tolerate if the conditions were known.

"The main point to be considered," said Mr. Morton, "is that the young people of our race have so few places where they can enjoy the healthy, simple pleasures. Mrs. Halicous, of the Elim House, is working faithfully in the interests of the girls, but teachers are needed, and frequently it is

difficult to make ends meet with the small sums of money donated."

¶ At a meeting of the Adelphic Literary Society of Augustana College, near Davenport, Ia., the program was devoted to "The American Negro of To-day." Orations on the Negro songs and musical selections by the white and colored students occupied the evening.

¶ Dr. W. E. B. Du Bois has been lecturing on the history of the Negro race at Howard University and in Virginia. He is making, this month, a lecture tour in Indiana, Missouri, California, Oregon, Washington, Oklahoma, Texas, Louisiana and Georgia.

PERSONAL.

"UNCLE" DANIEL SUGG, 82 years old, attends school regularly in the town of Hookerton, N. C. He owns a farm of 180 acres. When he was young he could not go to school, but now, having the means, he is determined to make use of the opportunity. His neighbors are making no effort to deny him the privilege, for "he is a fine specimen of the old-time darky and is very much liked by all the white people."

¶ William Cain, said to be the last surviving member of the original John Brown raiders, died recently in Winona, Minn.

¶ Mr. T. G. Nutter has been appointed a clerk in the land department of the office of the auditor-general of West Virginia.

¶ Miss Sophia B. Boaz, a graduate of the Kansas City High School and of Fisk University (1911), has been appointed a probation officer of Cook County, Ill.

¶ Samuel Ben Elchanan, an Abyssinian Jew, was found stranded in Cincinnati the other day. Dr. Boris D. Borger, of the United Jewish Charities, secured him employment.

¶ Mr. Jerome B. Peterson has been appointed deputy collector of internal revenue at San Juan, Porto Rico.

¶ The Hon. Charles A. Cottrill, collector of internal revenue at Hawaii, recently delivered an address on "Armstrong and Hampton" on the occasion of the unveiling of a tablet to General Armstrong at Oahu College. Commenting on the address, the *Commercial Advertiser* says:

"It was fortunate that there should be at this particular time in Hawaii so worthy a representative of the race that Armstrong fought to free.

"Looking back to those few weeks between the time of the announcement of the Cottrill appointment to the position of collector of internal revenue for this territory and remembering the opposition there was locally to his appointment because he is of Negro blood and contrasting the sentiments then expressed with the applause he received from the leading white and Hawaiian residents of Honolulu and the friendliness toward him evinced on every hand, it is plain that Mr. Cottrill has not only been an efficient official, but has shown himself to be a man able to gain a high place for himself in public esteem."

¶ Isaac D. Martin, of Pratt City, Ala., is the first Negro to receive a prize in the corn-club contest in Alabama. For producing 200 bushels on one acre he was awarded second prize of $150. There were more than 10,000 competitors, chiefly white farmers.

¶ Mrs. James Russell, a colored woman of Columbus, O., has patented a portable newsstand.

¶ Mr. Sterling Leeo, a colored man of Los Angeles, Cal., has patented a device for preventing wear and tear of railroad tracks. The invention has received the favorable consideration of several street-railway companies.

¶ Sam. Thomas, a colored wagon driver, rescued Mrs. Mary Keating, a white woman, from attempted suicide by drowning at Norfolk, Va.

¶ Thomas Galloway, of Ware, Ala., owns upward of 800 acres of land and is proprietor of three turpentine farms. He asserts that most of his success has come within the past five years.

¶ Mr. William Pickens has been elected president of the Alabama State Teachers' Association.

¶ The Rev. Wilbur O. Rogers, priest-in-charge of St. Philip's Episcopal Mission in Syracuse, N. Y., has accepted a position as teacher in the St. Matthias Industrial Training School, Atlanta, Ga.

¶ The Rev. G. A. McGuire, M. D., former rector of St. Bartholomew's, Cambridge, Mass., has accepted a living in the diocese of Antigua, B. W. I.

¶ Bishop Moses B. Salter, of the A. M. E. Church, died recently at Charleston, S. C.

A

¶ Joseph D. Bryan has invented an improved scrubbing brush which is now being manufactured and marketed at Milwaukee.

¶ "The Arabic Bible—a Plea for Transliteration" is the title of a posthumous work of Dr. S. W. Blyden now appearing from the press of C. M. Philips, of London.

¶ Mary Washington, the colored nurse and attendant of Mrs. Robert E. Lee, who is herself at present a patient in the hospital of the University of Virginia, at Charlottesville, has a Bible inscribed as follows:

"Mary Logan, from her friend, Mary Curtis Lee, Alexandria, 24th May, 1873."

¶ Jackson, a colored boy, won the 440-yard dash in the Occidental University Southern California meet.

¶ The Smart Set Athletic Club, of Brooklyn, conducted "one of the most successful meets held in the various armories this winter." Ted Meredith, of the University of Pennsylvania, won the J. B. Taylor memorial quarter-mile race. Howard Drew and other colored athletes scored in several events.

¶ Troop G, 10th U. S. Cavalry, Burlington, Vt., attended the British Columbia, Ottawa and Montreal horse show at Montreal.

¶ At a basketball meet in Manhattan Casino, New York, Howard University defeated the Monticello A. C. of Pittsburgh.

¶ The Hon. Henry T. Eubanks, a colored man who was three times elected to the Ohio legislature, is dead.

¶ Miss E. F. Wilson, of Washington, D. C., has been made assistant director of domestic science in the colored schools.

¶ Miss Marion Green, who is now attending Hillsdale College, Hillsdale, Mich., is a graduate of Storer College, Harper's Ferry. She is doing excellent work and is abreast with the best minds of the college. Out of more than 500 students, only four received the mark of A, she being one of the four. Miss Green is working her way through college by cooking for some of the private families.

MUSIC AND ART.

AT the "recital of songs by American composers," which was given March 6 at the MacDowell Club in New York City, "Since You Went Away," a song by the colored composer, J. Rosamond Johnson, was sung by Charlotte Lind, soprano.

¶ On February 22, at the Howard Theatre, Washington, D. C., the Howard University Dramatic Club presented Bulwer-Lytton's "Lady of Lyons." Miss Osceola McCarthy, in the rôle of Pauline, exhibited talent of a very high order.

¶ At the recent civic-welfare exhibit at the Newport, R. I., high school, many of the designs and plans were constructed by Wellington Willard, a student in the high school. In the president's report special mention was made of Mr. Willard's work in water colors.

¶ Will Cook's characteristic Negro songs have become popular with American singers in the South. "Exhortation" was lately sung by Frank Agar, of Texas Christian University,

B

who was the honor guest of the Harmony Club of Polytechnic College of Fort Worth, Tex.

¶ A Lenten musicale was given for charity at the home of Mrs. Albert S. Reed, New York City, on March 22. The program was presented under the direction of Mr. U. G. Chalmers.

¶ The music department of Sam. Houston College, of Austin Tex., one of the progressive freedmen's schools of the South, of which R. S. Lovinggood is president, has been reorganized this year under the efficient directorship of W. E. Lew, of Boston, Mass. The course embraces instruction in piano, voice, public-school music and choral work. A concert of much interest was given by the department on March 11, for which Professor Lew deserves considerable praise.

¶ Mr. James A. Mundy, composer of "Ethiopia," directed an emancipation chorus at the semi-centennial celebration in Chicago.

¶ Concerts and entertainments to help in the purchase of the home of the late Coleridge-Taylor are to be held in Boston, Washington, D. C., and Washington, Pa.

¶ G. Ricordi & Company have published two songs by J. Rosamond Johnson, with words by James W. Johnson: "Since You Went Away" and "The Awakening."

¶ At Mount Vernon, N. Y., a concert in behalf of St. Clement's Chapel was given by a number of white artists.

¶ Clarence Withington, 13 years of age, of Brooklyn, N. Y., was awarded a prize for his water-color work at the Brooklyn Hobby Show. There were 2,000 exhibitors and fifty-eight prizes were awarded.

¶ Madame Azalia Hackley, soprano, assisted by Kempner Harreld, violinist and director of the musical department of the Atlanta Baptist College, appeared at the Auditorium Armory at Atlanta, Ga., as conductor of the students' musical festival. Compositions by colored composers were given by a male chorus of 250 voices and the Atlanta Baptist orchestra. Commenting on this festival, the Atlanta *Journal* says:

"The musical festival and voice demonstration by Madame Hackley and students at Atlanta Baptist College drew an audience of 4,000 white and colored people to the auditorium. In addition to the large local

MELNOTTE, IN "LADY OF LYONS."

representation present, former students and alumni of the college were there from various other towns and cities in Georgia and Alabama.

"An interesting and varied program was rendered, consisting of exercises in voice culture, orchestral selections, old-time Negro melodies, instrumental solos and melodies by Negro composers, and renditions of Kipling's 'Rolling Down to Rio' and Gounod's 'Gallia,' by a male chorus of 250 voices.

"As a whole, the entertainment was very creditable. Many numbers elicited vigorous and enthusiastic applause from the audience."

¶ "Créole Candjo" is the title of a song, in the French patois of Louisiana, included in the repertoire of Madame Marcella Sembrich at a farewell recital in Carnegie Hall in New York.

THE GHETTO.

THE fate of the new Northern "Jim Crow" legislation is so far as follows: In Michigan the marriage bill was not reported from the committee.

¶ In Delaware the separate-car law may pass the house, but will not pass the senate.

¶ In California the separate-school law was killed in committee.

¶ In Colorado the separate-school law was voted down.

¶ The anti-marriage bill in Kansas passed the house but was killed in the senate committee.

¶ The anti-marriage bill in Iowa was indefinitely postponed by a vote of 27 to 16. This was the last of three bills introduced in that State.

¶ In the State of Washington the marriage bill was killed in the judiciary committee of the senate.

¶ In Missouri the separate-car law was killed in committee and the segregation bill was voted down.

¶ In Ohio the anti-marriage bill has been killed after a severe fight.

¶ In St. Louis, Mo., a colored woman who gained a position of stenographer by civil-service examination was rejected by Denis A. Ryan, the Irish assistant custodian of the custom house.

¶ In Chicago, Ill., 1,000 white women refused to dine at the Hotel La Salle because the management would not seat the Negro delegates.

¶ The Levy bill, providing against discrimination on account of race or color, has passed the New York assembly and now goes to the senate.

¶ At the Progressive party conference at Baltimore colored delegates were not allowed to use the elevators in the hotel.

THE COURTS.

THE Massachusetts Supreme Court has held that a slave marriage must be regarded as a lawful marriage. The decision was won by Mr. Clement G. Morgan in a case which had been decided against him in the lower courts.

¶ The Supreme Court of Florida has recently had before it the case where in eight years the sheriff had drawn no colored man on the jury. The court declared:

"We have held in effect that our statutes on the subject of the selection of jurors do not discriminate, and do not authorize discrimination against any person for jury service because of race or color. But that if the executive officers charged with the duty of executing such statutory provisions deliberately, in the execution thereof, discriminated against Negroes because of their color or race, it would be not only a violation of our statutes, but would violate the provision of the Fourteenth Amendment to the Federal Constitution, and would render their actions null and void in any case in which such discrimination occurred." (Montgomery vs. State, 55 Fla. 97, 45 South Rep. 879.)

Mr. I. S. Purcell was the attorney who won this case.

¶ In Georgia a colored man was accused of assault on two white women of notorious reputation. The evidence was flimsy and the jury found the defendant guilty of criminal assault, but recommended that he be punished as for a misdemeanor. The court allowed the white audience to vote on the subject. They were divided in sentiment, but the judge gave the colored man a severe sentence. The governor pardoned the colored man.

CRIME.

LYNCHINGS have occurred as follows: At Mondak, Mont., a Negro, for shooting the sheriff and his deputy.

At Union City, Tenn., one colored man, for the murder of an aged white man.

At Issaquena, Miss., a colored man, for the murder of a white man.

At Albany, Ga., a colored man, for no apparent reason.

In the county jail at West Point, Miss., a colored man, for an assault upon the sheriff.

At Kosciusko, Miss., and at Marshall, Tex., colored men, for alleged assaults on white women.

At Springfield, Miss., Hickory, Miss., and Pensacola, Fla., colored men, for murderous assaults on white men.

¶ The Pennsylvania legislature is considering a bill to abolish lynching by subjecting the sheriff to forfeiture of office and the payment of a fine to the relatives of the lynched man.

A

ALPHA'S BET IS NOT OVER YET POSTER COMMISSIONS

For Alpha's Bet Is Not Over Yet, artists Steffani Jemison and Jamal Cyrus commissioned posters from sign painters, graphic designers, and contemporary artists. To create their new works, artists were inspired by diverse approaches to literacy—approaches that engage, challenge, and critique homogeneous systems of knowledge and power.

REGINA AGU

FIRELEI BÁEZ

JAMAL CYRUS

NATHANIEL DONNETT

CHITRA GANESH

TIA-SIMONE GARDNER

STEFFANI JEMISON

NIKKI PRESSLEY

ROBERT PRUITT AND AUTUMN KNIGHT

BOBBY RAY

MARTINE SYMS

GINGER BROOKS TAKAHASHI

¶ REGINA AGU

Take My Word, 2011
Wide-format Print
Courtesy the artist

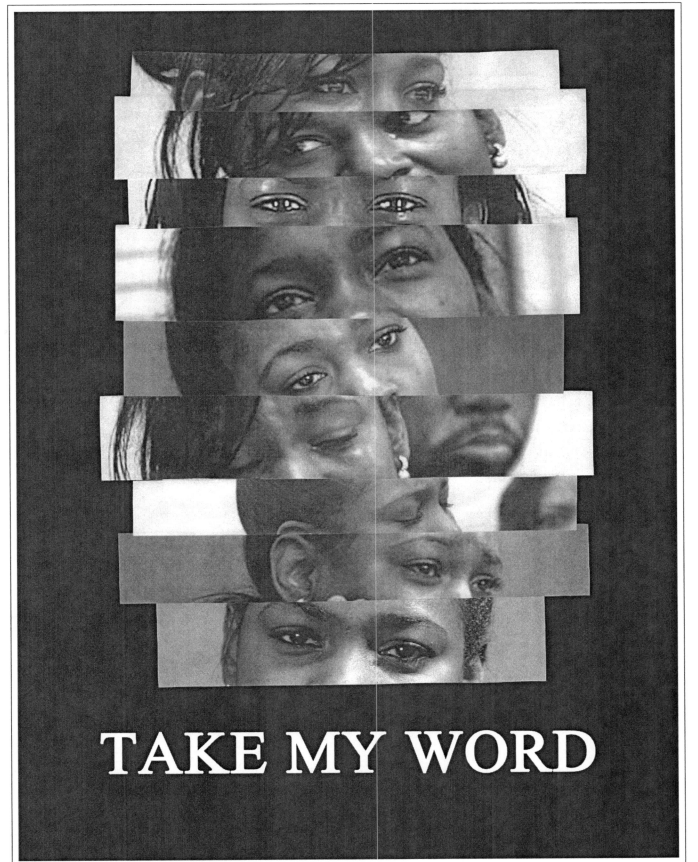

TAKE MY WORD

D

¶ FIRELEI BÁEZ

Editable: Limitations, 2011
Wide-format Print
Courtesy the artist

D

¶ JAMAL CYRUS

Multiple Choices, 2011
Wide-format Print
Courtesy the artist

This appropriation of form is _____.
a. A lame ass bait & switch.
b. A masterful collaboration on behalf of govermental and corporate powers.
c. A good reason to go dancing in the streets (wink, wink)
d. All of the above.

¶ NATHANIEL DONNETT

Yes We're Open, 2011
Wide-format Print
Courtesy the artist

The Reader Restaurant

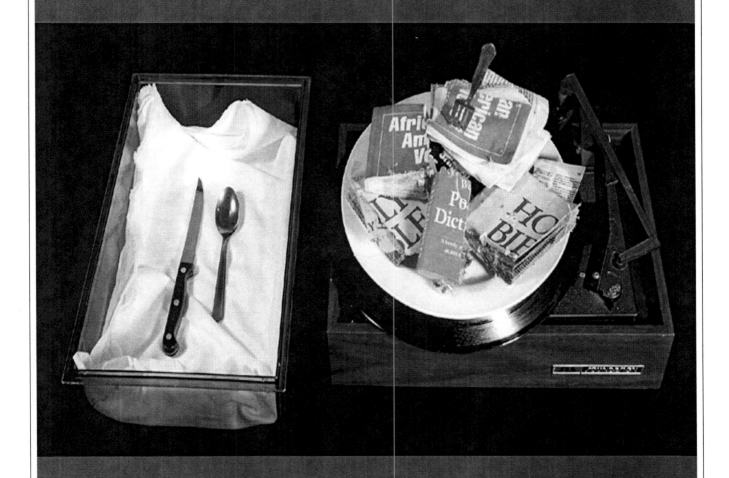

Menu

Open 7 Days A Week - 24 Hours A Day

over a million served

D

¶ CHITRA GANESH

Kaleidoscopic, 2011
Wide-format Print
Courtesy the artist

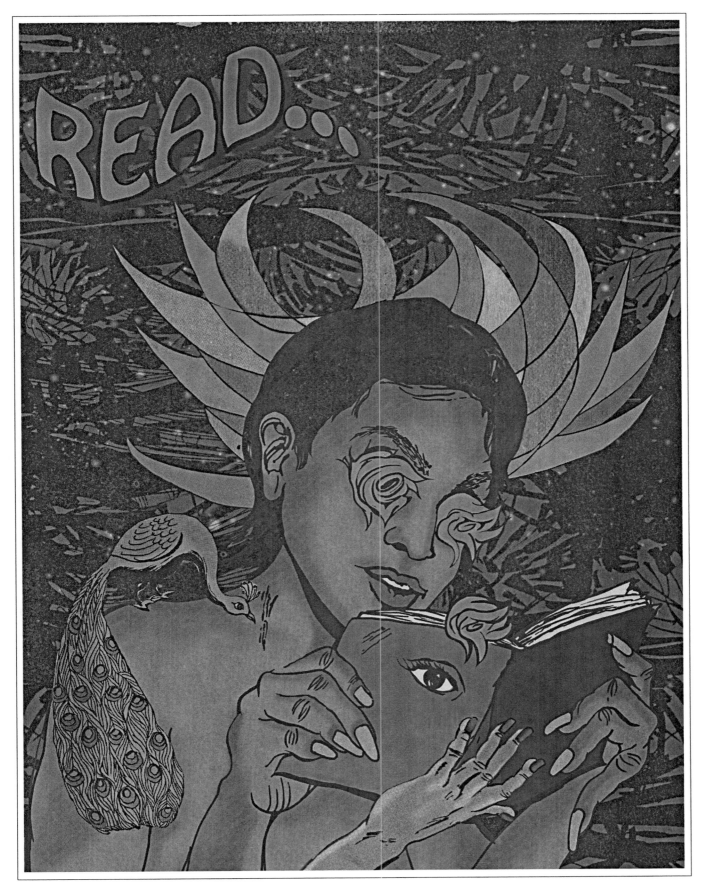

D

¶ TIA-SIMONE GARDNER

Liberation Times, 2011
Wide-format Print
Courtesy the artist

Liberation

Established sometime after MDCCXX · Made Possible by the Spoken and Writing Words of Formerly Enslaved People · Free

"The more I **read**, the more I was led to abhor and detest my enslavers."

"It gave me the best assurance that I might rely with the utmost confidence on the results which, he said, would flow from teaching me to **read**."

"I resolved, therefore to **write** letters from the north from time to time."

"She can **read** and **write**, and in all probability will try to get to the Free States."

"After all, I shall **read** your book with trembling for you."

"As a young boy he was sent to Baltimore, to be a house servant, where he learned to **read** and **write**, with the assistance of his master's wife."

"Without stopping to **write** a long apology for offering this little volume to the public, I shall commence at once to pursue my simple story."

"She could neither read nor **write**, and when the bill of sale was made out, she signed it with a cross."

"During this time my copy book was the board fence, brick wall, and pavement; my pen and ink was a lump of chalk. With these, I learned chiefly how to **write**."

"I was invited to attend, because I could read."

"I had felt, seen, and heard enough, to **read** the characters, and question the motives, of those around me."

"That slavery, in all its phrases, is demoralizing to every one concerned, none who may **read** the following narrative, can for a moment doubt."

"She told them it had not been revealed to her, perhaps if she could **read**, she might see differently."

"I asked him if he didn't know it was contrary to law; and that slaves were whipped and imprisoned for teaching each other to **read**."

"The tale of my own sufferings is not one of great interest to those who delight to **read** of hair-breadth adventures, of tragic occurrences, and scenes of blood—my life, even in slavery, has been in many respects comparatively comfortable."

Just at this point of my progress, Mr. Auld found out what was going on, and at once forbade Mrs. Auld to instruct me further, telling her among other things, that it was unlawful as well as unsafe to teach a slave to **read**.

"It is not only unlawful for slaves to be taught to **read**, but in some of the States there are heavy penalities attached, such as fines and imprisonment, which will be vigorously enforced upon any one who is humane enough to violate the so-called law."

"While I was with her, she taught me to **read** and spell; and for this privelge, which so rarely falls to the lot of a slave, I bless her memory."

"They knew that I could **read**; and I was often asked if I had seen anything in the newspapers about white folks over in the big north, who were trying to get their freedom for them."

"This has not left me much leisure to make up for the loss of early opportunities to improve myslef; and it has compelled me to **write** these pages at irregular intervals, whenever I could snatch an hour from household duties."

You remember the old fable of "The Man and the Lion," where the lion complained that he should not be so misrepresented "when the lions wrote history." I am glad the time has come when the "lions **write** history."

" **INDICTMENT.**

COMMONWEALTH OF VIRGINIA, } *In the Circuit* NORFOLK COUNTY, *ss.* } *Court.* The Grand Jurors empannelled and sworn to inquire of offences committed in the body of the said County on their oath present, that Margaret Douglass, being an evil and disposed person, not having the fear of God before her eyes, but moved and instigated by the devil, wickedly, maliciously, and feloniously, on the fourth day of July, in the year of our Lord one thousand eight hundred and fifty - four, at Norfolk, in said County, did teach a certain black girl named Kate to **read** in the Bible, to the great displeasure of Almight God, to the pernicious example of others in like case offending, contrary to the form of the statute in such case made and provided, and against the peace and dignity of the Commonwealth of Virginia.

"VICTOR VAGABOND, Prosecuting Attoryney."

"One day he caught me teaching myself to **write**. He frowned, as if he was not well pleased."

"In learning to read, I owe almost as much to the bitter opposition of my master, as to the kindly aid of my mistress."

"After a brief period of surprise, the will of my mistress was **read**, and we learned that the law would not allow to her slaves a daughter, a child of five years old."

"I looked forward to a time at which it would be safe for me to escape. I was too young to think of doing so immediately; besides, I wished to learn how to **write**, as I might have occasion to write my own pass."

"This... I longed to **read** and **write**. The alphabet while so hungry, but on the writing chore... such as I have had from such a... from learning so little; we, at first hid that it was a source of sorrow for any one that does so under... can to become **read** and... **write**."

"Trusting that this may be the impression produced by your narrative, wherever it is **read**, and that it may be **read** wherever the evils of slavery are felt..."

"...he said a white man may do what he pleased, and he could not be lost: he might lie, and rob the slaves, and do anything else, provided he **read** the bible and joined the church."

"While they gazed on these clouds, they saw them open and two bags of different size drop from them. They immediately ran to lay hold of the bags, and unfortunately for the balck man — he being the strongest and swiftest — he arrived first at them, and laid ohold of the bags, and the white man, coming up afterwards, got the smaller one. They then proceeded to untie their bags, when lo! in the large one, there was a shovel and a hoe; and in the small one, a pen, ink, and paper, to **write** the declaration of the intention of the Almight: they each proceeded to employ the instruments which God had sent them, and ever since the colored race have had to labor with the shovel and the hoe while the rich man works with the pen and ink!"

D

¶ STEFFANI JEMISON

"Good luck to you all, you're going to need it," 2011
Wide-format Print
Courtesy the artist

don on March 14, 2009 11:22 AM
there is a serious problem in the U.S. for being one of the wealthiest nations, it still has a third world nation soul. The U.S. has poverty beyond the scope of their intelligence, hence majority of U.S soldiers cannot do math nor do they possess any writing skills whatsoever.

BATMAN on March 14, 2009 11:38 AM
Chicago Needs a BATMAN, now that ever, to clean up this mess.

Irene on March 14, 2009 2:53 PM
Graduated with my granddaughter a very cleancut good kid
They are devastated. A sad sad day. We are praying that God will intervene in this travesty that has turned our children
into coldblooded monsters. Many have turned from God and placed Him on the backburner. Our entire nation is is trouble.Only God can help us. We need supernatural intervention. PRAY! PRAY! Repent!! God is merciful.We need
His mercy!! the young people are left on their own.
Waiting at the stop sign I looked at the kids next to me
the eyes were empty and cold. Listening to filth over
the radio. Being programed to be monsters. It's a devil's
scheme!

EBJ on March 14, 2009 6:03 PM
Do'nt give up on GOD.He makes no mistakes.Personally I can't conceive my only daughter being being ravaged that way.
We have to wait on the Lord.It's evident this shooting was
going to happen,and that those children would be in that area
at the wrong time. So thank you Lord for sending that unconditional Saint on earth long before they where born or even thought of, those to little ones that where in the car with him. He had to be an angle.Thank you Lord.Thank you Lord
Thank you Lord.

Bubba on March 14, 2009 6:11 PM
A few questions:

1. What was a 14 year old doing out with a 4 year old and a 4 month old after curfew? The article says he left a basketball game

2. How was the kid shot, with a handgun? Handguns are banned in Chicago, it's not possible.

3. According to the article, Brittani Orange didn't know he was shot until she pulled up in front of the house. How did the kid become a hero who covered the small children to protect them if nobody even knew he was slumped over?

4. Why do you people continue to vote for the same politicians who have done nothing for you? Oh, I forgot, they're Democrats and that's the only vote you'll ever cast.

5. With all the shootings after basketball games, why does any concerned parent let their kid go to a basketball game?

Glenn on March 14, 2009 7:18 PM
Parents? The parents of these kids don't care about or for them, then something like this happens and the blame game starts. Go ahead, blame everybody except yourself. FOOLS. Another thing, the posts here show a real lack of interest in elementary education. The grammar, spelling and structure shows that. Good luck to you all, you're going to need it.

MELANIE on March 14, 2009 11:03 PM
HI MY NAME IS MELANIE AND I ATTEND HILLCREST HIGH SCHOOL IN COUNTRY CLUB HILLS I ALSO ATTENDED PRAIRIE HILLS WITH GREGORY ND I MUST SAY I AM SHOCKED THAT A FRIEND OF MINE HAD TO LEAVE THE WORLD IN PAIN WHEN I HEARD THAT HE WAS KILLED BY THAT IDIOT I STARTED TO BREAK INTO TEARS GREG WAS A FUNNY DUDE I MUST SAY HE LOVED HIS BASKETBALL BUT GREG I WILL ALWAYS KEEP U IN MY HEART AND MY CONDOLENCES GO OUT TO HIS FAMILY MY HEART IS BROKEN BECAUSE GREG WAS LIKE A BESTFRIEND I AM DEEPLY SADEN TO LOOSE A GOOD FRIEND LIKE HIM GREG ILL MISS U BOI.
{{R.I.P GERG}}

D

¶ NIKKI PRESSLEY

it's a poor sort of memory that only works forward, 2011
Wide-format Print
Courtesy the artist

D

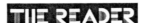

¶ ROBERT PRUITT & AUTUMN KNIGHT

Reach the Stars, 2011
Wide-format Print
Courtesy the artists

Reach The Stars
With A Book

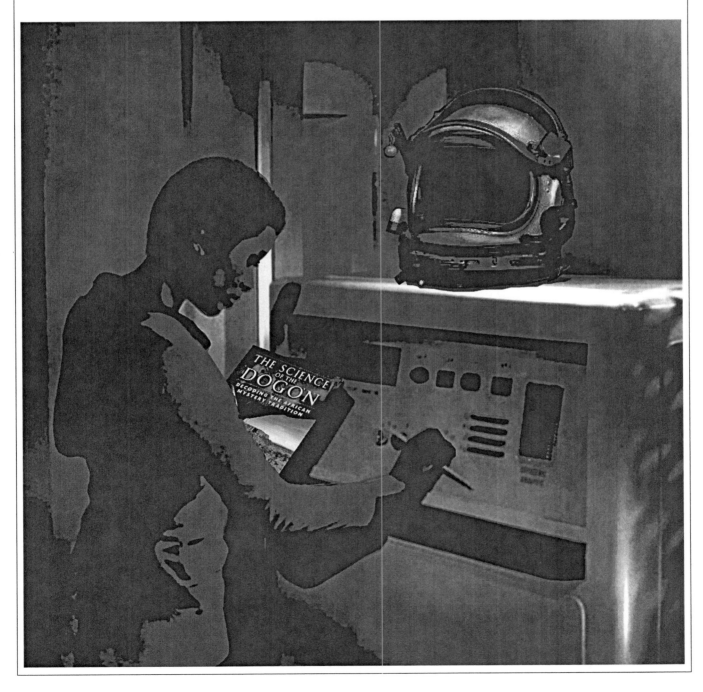

¶ BOBBY RAY

Ice Letters, 2011
Wide-format Print
Courtesy the artist

D

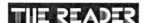

¶ MARTINE SYMS

Johnson Publishing Company Building, 1971, 2011
Wide-format Print
Courtesy the artist

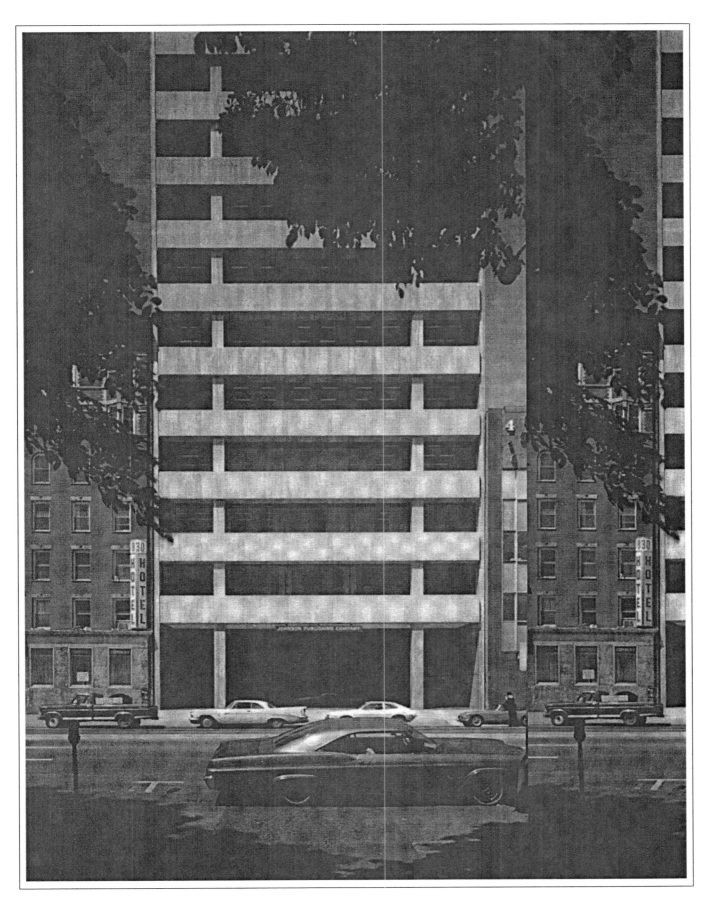

D

¶ GINGER BROOKS TAKAHASHI

James Baldwin in rural Vermont, 2011
Wide-format Print
Courtesy the artist

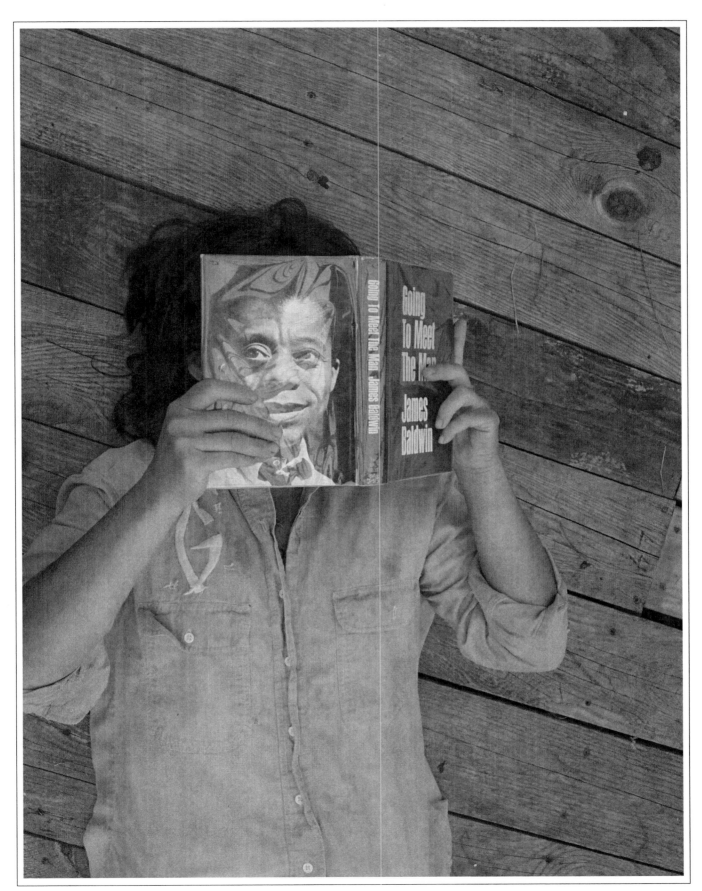

A

ALPHA'S BET IS NOT OVER YET
CHAPBOOKS AND ZINES

For Alpha's Bet Is Not Over Yet, artists inspired by the power and complexity of the printed word were invited to share their self-published zines, print-on-demand magazines, and hand-crafted chapbooks, many of which were created specifically for the exhibition.

TERRY ADKINS

ADEBUKOLA BODUNRIN

NSENGA KNIGHT

DAVID LEGGETT

ELIZA MYRIE

PAUL MPAGI SEPUYA

MITCHELL SQUIRE

MARTINE SYMS

GREG TATE & LATASHA N. NEVADA DIGGS

TERRY ADKINS

Antique Blacks, 2010
Letterpress book
19 x 12.5 x 1 in.
Courtesy the artist

THE ANTIQUE BLACKS

BEING AN ANNOTATED DIRECTORY WHEREIN IS CONTAINED
THE LISTINGS OF FREE BLACK AMERICAN CITIZENS
WHO RESIDED AND FLOURISHED AT THE BOROUGH OF BROOKLYN
IN THE GREAT EMPIRE STATE OF NEW YORK AND WERE
FORMERLY DENOTED BY ASTERISKS IN THE GENERAL DIRECTORIES
OF THE DARK AND DISTANT YEARS 1832-1833, 1847-1848, 1850 -1851
COMPILED AND LISTED IN ALPHABETICAL ORDER OF FAMILY NAMES
INCLUDING ADDRESSES, NOBLE VOCATIONS, ADVERSE CONDITIONS,
EARNEST OCCUPATIONS & VISIONARY ENTREPENUERIAL ENDAEAVORS

By a principle essential to Christianity, a person is eternally differenced from a thing;
so that the idea of a human being necessarily excludes the idea of property in that being.
COLERIDGE

COMPILED & EDITED BY THE ARTIST TERRY ADKINS

UNDER THE AUSPICES OF THE LONE WOLF RECITAL CORPS
AT THE BEHEST OF THE SACRED ORDER OF TWILIGHT BROTHERS
BLANCHE BRUCE, MINISTER AT LARGE

PHILADELPHIA
COMMON PRESS
UNIVERSITY OF PENNSYLVANIA
2010

ADEBUKOLA BODUNRIN

Doing Good but Behaving Badly, 2011
Pop-up color book with illustrations
4.5 x 4 in., 32 pages
Edition 1 of 2
Courtesy the artist

A

NSENGA KNIGHT

A Guide to the Last Rite, 2011
Black and white lithographic print
6.5 x 6.5 in.
Edition of 80
Courtesy the artist

A GUIDE TO THE
LAST RITE

THE DECEASED SHOULD BE PLACED IN FRONT OF THE IMAM. BEFORE STARTING THE PRAYER, AS USUAL WITH EVERY SALAH, THE NIYYAH (INTENTION) SHOULD BE MADE. IT IS NOT NECESSARY TO PRONOUNCE THE NIYYAH IN WORDS, SINCE THE NIYYAH COMES FROM THE HEART. NIYYAH MEANS TO HAVE THE SINCERE INTENTION OF PRAYING FOR THE DECEASED.

IN JANAZAH THE ENTIRE PRAYER IS DONE IN STANDING POSITION. IT IS RECOMMENDED THAT THE PRAYER LINES BE ODD IN NUMBER, FOR EXAMPLE THREE OR FIVE. THE IMAM MAY LEAD THE PRAYER WITH THE FAMILY'S PERMISSION.

STEPS TO BE TAKEN IN A JANAZAH (FUNERAL PRAYER)

1. THE IMAM SHOULD PRONOUNCE TAKBEER SAYING: ALLAHU AKBAR (GOD IS THE GREATEST)

2. RECITE SURAH FATIHAH, THE OPENING CHAPTER OF THE QURAN

3. PRONOUNCE A SECOND TAKBEER

4. READ THE BENEDICTIONS ON THE PROPHET. ONE IS GIVEN BELOW:

> "O ALLAH, BESTOW YOUR FAVOR ON MUHAMMAD AND ON THE FAMILY OF MUHAMMAD AS YOU HAVE BESTOWED YOUR FAVOR ON IBRAHIM AND ON THE FAMILY OF IBRAHIM, YOU ARE PRAISEWORTHY, MOST GLORIOUS. O ALLAH, BLESS MUHAMMAD AND THE FAMILY OF MUHAMMAD AS YOU HAVE BLESSED IBRAHIM AND THE FAMILY OF IBRAHIM, YOU ARE PRAISEWORTHY, MOST GLORIOUS."

5. PRONOUNCE A THIRD TAKBEER. ONE SHOULD PRAY FOR MERCY AND FORGIVENESS ON BEHALF OF THE DECEASED. HE MAY RECITE ONE (OR MORE OF SEVERAL) DU'AS TRANSMITTED FROM THE PROPHET (UPON WHOM BE ALLAH'S BLESSINGS AND PEACE). ONE IS GIVEN BELOW:

> "O ALLAH, YOUR MALE SLAVE AND THE CHILD OF YOUR FEMALE SLAVE IS IN NEED OF YOUR MERCY, AND YOU ARE NOT IN NEED OF HIS TORMENT. IF HE WAS PIOUS THEN INCREASE HIS REWARDS AND IF HE WAS A TRANSGRESSOR THEN PARDON HIM."

6. SAY A FOURTH TAKBEER

7. MAKE SALAM EITHER ON ONE (RIGHT) SIDE OR ON BOTH SIDES.

DAVID LEGGETT

Until Friday, 2006
Black and white inkjet print, stapled
6 x 6 in.
Courtesy the artist

there is this girl i really like.
i want her to be my Girlfriend but
she claims she just doesn't know yet
she acts as if we are together. she
holds my hand and Kisses me among
other things. she told me she'll
make her decision wether or
not she wants to be my girlfriend

until then we will not talk to each other
she says until friday it's

SUNDAY

ok ok who the fuck is she?
Fuck you Abbigail friday my fucken
ass.

i wanna
DROWN
you and
Your fish

BOOK

Monday, Oct. 2, 20

maybe
i'm just ugly

ugly + fat

ELIZA MYRIE

brownfacewhiteface, 2011
digital color photographs
5.833 x 8.264 in., 51 pages
Courtesy the artist

PAUL MPAGI SEPUYA ❀

Studio Work, 2011
Black and white with spot color on heavyweight newsprint
8 x 10 in., 60 pages
Courtesy the artist

PAUL MPAGI SEPUYA
STUDIO
WORK

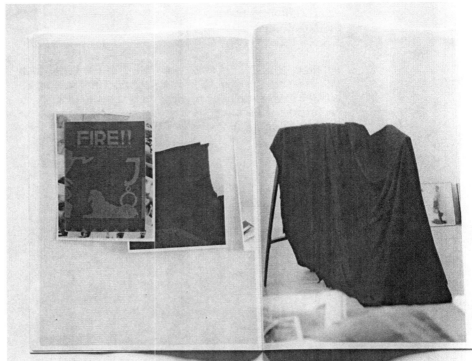

MITCHELL SQUIRE

Mitchell Squire
FOA vol.2 Digitalia: the itty bitty digit teaser," 2002 designed by Peter
Correll shrink-wrapped, loose leaf, full color, digital animation flipbook
(assembly required) edition of 500 (100 special editions include binder
clips, X-ACTO and metal rule)
5 sheets per pack, each a different "flavor," totaling 10 flipbooks per pack
2 ¾ x 1 ¼ x 7/8 inches individual assembled flipbook with clip
(NOTE: see 2' in attached image)
11 x 17 inches poster pack

Mitchell Squire, "FOA vol.4 Designo Criminale," 2004 designed by
colleague Charles Masterson (on behalf of Shaun Liboon) hand drawn,
saddle stitched, black & white zine in plastic cover unlimited edition
38 pages, illustrated
8 ½ x 11 inches

Mitchell Squire, "FOA vol.6 Non-Mint," 2006 designed by Jonathan
Muecke vacuum-sealed, perfect bound, full color monograph in black
rubber sleeve includes a surprise gift inside, edition of 20 with signed
certificate of authenticity 100 pages, illustrations and photographs
7 ½ x 9 ¾ inches (package: 11 x 17 inches)

MARTINE SYMS

Grape Juice, 2011
5 x 7.5 in., 12 pages
Black and white laser print
Edition of 50
Courtesy the artist

Grape Juice

GREG TATE &
LATASHA N. NEVADA DIGGS

Coon Bidness: The Critical Ass Issue, 2011
Perfect-bound color magazine
8.5 x 11 in., 124 pages
Unlimited edition
Courtesy the artists

Greg Tate

ART · PHOTOGRAPHY
Sanford Biggers ·
Wangechi Mutu ·
Xaviera Simmons ·
Ayana V. Jackson ·
Marilyn Minter ·
Sane Woods ·
Arthur Jafa ·
Thomas Sayers Ellis ·
Simone Leigh ·
Cindy Cha ·
Vladimir Cybil ·
Diane Wah ·
Collette Valli ·
Duane Deterville ·
Didier Williams ·
Krista Franklin

POEMS · STOR
Charles Joseph
Kevin Simmon
Edwin Torres
Toni Asante
Avery Young
L'Oreal ·
Angel Nafi
Paul Hark
Urayoan
Karma M
Shariff
Michae
Dougla
Kim G
Aaro
jessi

GF
A

SHORT STORY COMPETITION

A number of stories have been sent us in response to the invitation to our CRISIS readers. We may roughly divide them into three groups:

Didactic stories. Some of these have had good plots, others none, but nearly all have been hurt artistically by the always present desire to instruct the reader. This is a common fault among writers in America. An able critic has said of us: "We are preachers, not artists."

Old-time "darky" stories. From the literary viewpoint these have been the best. But the most of them have been too evidently old time, copying a style so well known as to be stereotyped. We want humorous tales, but we would like them in a little less threadbare clothes.

Character sketches. The story that we print below comes under this head. It is slight, but it bears the stamp of sincerity and truth. It shows us a young colored girl from a viewpoint new to many. It interprets for us a bit of human life.

We hope that our readers will send us other stories. We want the good plots well worked out; we want merriment and laughter; we want pictures of the real colored America.

THREE STORIES

MITCHELL S. JACKSON
EXCERPTS

FROM "OVERSOUL"

 FEW DAYS after the festivities, I hit the mall with my kickstart dough—scrilla the old me might've used to cop a sack—stuffed in a pocket and buy a white shirt and a blue shirt and a pair of khakis and a pair of polyester blend slacks and a new tie and some hard soled shoes and the next day scour the city in search of HELP WANTED signs and, with worry I hope is semi-veiled, enter corner stores and grocery stores and liquor stores and car lots and car washes and pawn shops and restaurants and blood banks and gas stations and warehouses and dry cleaners to fill out application after application hoping somebody with some authority or compassion or both will hazard a call to the number I listed, which truthbetold is my mama's home phone—a line she guards the way a Rottweiler or Doberman protects its owner—praying at least one person on planet earth will ring me for an interview, but since they don't, I'm left a whole morning gawking at a contraption (a rotary joint) I've tried more than once to coax alive by ESP; unsuccessful as shit till near noon when I dress and, since a nigger's license is

suspended till the day after judgment, slug out to catch the light rail or the bus or if I'm lucky to bum a ride or if I'm less fortunate to trek infinite blocks on foot to a whole new set of places taunting my soon to be destitute-self with virtually unavailable options, conceding my poor chances but filling out apps against the odds—every time wishing like crazy I had a whole other life history to list—before trudging home to pick at leftovers, count my steady-dwindling fund, stab at sleep, and do it all over again, repeating the same script for so many mornings it takes on the feeling of a life sentence, repeating the same script so many mornings that one morning I backtrack to the mall where I copped my as yet unworn interview clothes, to ask security, stock boys, salesmen, managers, anybody with a name tag or a black or white button down, for an opening, any opening at all, though there ain't no HELP signs in view, questions that harvest a fusillade of no's, and since you can only stand but so many public setbacks, for the next who knows how long, I spend hours upon hours at the employment office searching listings that appear so far outside my realm of possibility as to be excerpts of science fiction, reading the fantasy paragraphs till I'm good and abased, then trudging home to eat, watch another eon of depressing news, count the last of my last few bucks, and on the bleakest nights, lay on the flattened twin mattress in the room above my mama's head with the tepid hope my eyes stay the fuck closed forever, but since a nigger's wishes materialize about never, early the next AM, an anonymous force tugs me about of bed and sends me slugging downstairs to post by a phone that if it rings at all, is a creditor or telemarketer, still, since it sometimes requires more heart to give up than it does to go on, with a gloom my punk-ass prays is camouflaged, I shamble out of the house and into the jagged teeth of another day.

FROM "AFTER EVERYTHING"

ou want to know what it feels like to be me, to be me for at least a moment?

Here's what you do: Have a baby on the one you call baby, on a woman who, by comparison, cast butterflies, lady bugs, and bunny rabbits in the same light as serial killers, the most loyal woman you could meet in eons of blessed lives. Make sure the baby is born after you help her rehab from the wreck that killed forever her mother, sister, and dearest cousin, an accident that saw her only son head-banged into a coma and she ambulanced to ICU with a ruler-long gash in her side. Make sure you have a baby on your baby no more than a few years later: a time when she's nursed back to near health and her formerly comatose son is a starry-eyed invalid. Be certain it postdates the seasons and seasons she held you down—and I mean held you down to the nth power: regular letters, weekend visits, nasty flicks, even collect call acceptance past the time the bill approached national debt status—yeah, held you down like that! Make sure it's post the wreck and judge-ordered take-this-time-and-sit-your-punkass-down vaca.

Trust, life is timing.

By necessity it can only succeed the day you approach this super-bad in a parking lot and fill her head full of the grandiose drag your uncles applaud. It must be months beyond when you and the superbad start fucking, after she claims she can't have babies—a lie you accept so you can hit raw!—and yes oh yes, it follows the night the superbad cries you're her end-all-be-all.

Timing, timing. One day while you're asleep—slumbered in a bed in which you and your sweet baby have lain, hugged, sat, laughed, cried, dreamed, conceived, bled, fought, lost, loved—while laying in that bed, you are slapped conscious. When your eyes open, there's your baby, in sky blue work digs, hovering with a letter in hand, her eyes leaking mascara, and hazardous breath.

THREE STORIES

"You dirty bastard. After everything this is what you do," she says. "To me! This is what you do," she says, "to us!"

FROM "HEAD DOWN, PALM UP."

he man motions me closer, flaunting the only ring he wears—probably his only ring left to wear—a pinky joint set with an ambit of murky diamonds, and warns we can't let this highgrade reach the wrong ears. Then he pauses for what's likely the sake of suspense, says, "You've got to have tools G O T D A M N Y O U M E, meaning your rides, your crib, your clothes, your gold, you've got to, but all you got's a molehill without a mouthpiece." He points at his cracked lips, opened with a sliver of space between them, a pipe-smoker's lips, forever scorched. "And those gorilla moves," he says, "I S W E A R F O G O D try em and see don't they get you nothin less than more of what you never wanted. That gorilla ain't bout nothin," he says. "A smart one comes from here," he says, and touches his temple, "never from here," he says. He assumes a southpaw's stance and shakes miniature fists with abnormally big un-bruised knuckles.

Unc switches to orthodox and says G O T D A M N Y O U M E again for God only knows.

Okay, now is as good a time as any to ask, good people, if you'd please, please, preempt the hatetrocity. He's my Unc, all right. My real blood relative.

"Say, Nephew," Unc says. "This how you play it. Soon as you knock one, you keep your head down and palm up. Head down. Palm up," he says again, assuming the pose. He stands a while after, a Buddhist maybe, lanky limbs hanging, lank neck sprouting out of his weathered silk shirt, double-creased slacks, second-hand gators spraddled, big-knuckled babyish hands unfurled to show nails long enough to dredge coke, sharp enough to cut steak.

To be true, Unc is sympathetic almost with what the years.

A

FREEDWOMEN

KITCHEN
KOLUMN

his month's Kitchen Kolumn is a return to origins. Perhaps like many of our readers, The Bureau was brought up during the moment when some freedwomen threw off the chains of kitchen labor, leading to, among other things the culinary tragedy of Jiffy Box instant corn muffin mix. Only when we became the mistress of our own pots in the dawn of young freedwomanhood did we go in search of our foremother's kitchens and learn to prepare what we fondly refer to as "scratch cornbread." For this, the most important ingredient is a black cast-iron skillet, well-seasoned, best if handed down. (A charming variation, perfect for entertaining, is to use those cast-iron corn muffin molds which bake the cornbread into miniature corn cobs.) Another necessity is to liberate oneself from the insidious notion that cornbread should taste like dessert. Save your sweetness for the taste of freedom.

NB: We realize that many of our fellow freedwomen have proclaimed dietary emancipation and are now dairy-free, egg-free and/or gluten-free. While we have heard of vegan cornbread, we have not attempted it, and thus cannot offer guidance.

NB2: Also, some purveyors of so-called nouveau soul food cuisine propose variations on the classic recipe with such novelties as "ginger cornbread," "banana maple pecan cornbread," and "quinoa cornbread" (therefore not cornbread at all). We cannot offer guidance on that, either. Suffice to say, we are not inclined to attempt such transplants when it comes to the marrow of this tradition.

Seves 6-8 (easily scalable to 40 million)
Time: 10 minutes plus 25 to bake

Equipment Mise en Place
For this recipe you will need a well-seasoned 8- to 9-inch cast-iron skillet, a large bowl, a whisk, a 4-cup glass measure, and a rubber spatula.

INGREDIENTS
2 1/2 cups (12 ounces) coarse yellow cornmeal (some recipes call for "white cornmeal", ours does not)
1 teaspoon fine sea salt
1 1/2 teaspoons baking powder
4 tablespoons salted butter, melted and lukewarm
1 large egg, room temperature, beaten
1 1/2 cups whole milk, room temperature (we like to use buttermilk)
1 1/2 teaspoons vegetable oil

continued from Kitchen Kolumn

DIRECTIONS

1. Adjust the racks to the lower-middle and upper-middle positions and heat the oven to 425 degrees. Heat an empty 8- to 9-inch cast iron skillet over medium-high heat for 10 minutes.

2. While the skillet heats, turn the cornmeal, salt, and baking powder into a large bowl and whisk to combine.

3. Pour the melted butter into a 4-cup glass measure. Add the egg and whisk until smooth. Add the milk and whisk until smooth. (If the surface of the liquid appears beaded with butter, warm the glass measuring cup and its contents in the microwave for 20 seconds.)

4. Pour the wet ingredients into the dry and whisk lightly until smooth. The batter will be fairly thin. Add the vegetable oil to the hot skillet and tilt to distribute the oil. Scrape the batter into the skillet with a rubber spatula—it should sizzle. Immediately place the skillet on the lower oven rack and bake for 15 minutes. Transfer the skillet to the upper rack and continue baking until the cornbread is golden brown on top and tests clean with a toothpick, 5 to 10 minutes more. Remove the skillet from the oven and invert the cornbread onto a cutting board

From time to time, we receive correspondence from far-flung freedwomen seeking solace and counsel as they trod the stony road. Space permits that we can answer but so few.

Dear Sojouner,

I feel so conflicted. My friends have all started calling themselves "post-black," but it just doesn't feel right to me. Don't get me wrong, I love skinny jeans and TV on the Radio as much as the next girl, but I can't help but feeling just, you know, black. I don't want to be left behind. Please help.

Sincerely,
Medicine for Melanin-choly

Dear Miss MfM,

Your question couldn't be more timely. Dr. Sojouner has been handing out many prescriptions for the post-black blues. It's true that we are alive at a time when so much is changing and so rapidly, that cultural gatekeepers and cable-TV pundits are eager to announce a changing of the guard. I remember well in my girlhood when

WE ARE LISTENING TO:

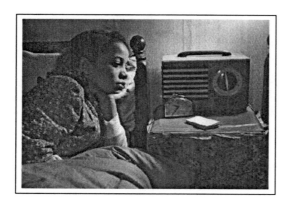

OUTKAST, "LIBERATION"
ROBERTA FLACK, "COMPARED TO WHAT"
SHABAZZ PALACES, "FIND OUT"
BLACK STAR, "THIEVES IN THE NIGHT"
SWEET HONEY IN THE ROCK, "ELLA'S SONG"
TRICKY, "BLACK STEEL"
VOICES OF EAST HARLEM, "RIGHT ON,
BE FREE"
ERYKAH BADU, "TWINKLE"
JOHN COLTRANE, "ALABAMA"
VERA HALL (RECORDED BY ZORA NEALE HURSTON
AND ALAN LOMAX) "ANOTHER MAN DONE GONE"

Jesse Jackson declared us all African-American; how it tripped so infelicitously off the collective lip. To think how we now embrace its full polysyllabic splendor! While it is true that, as Fanon told us, "each generation must out of relative obscurity discover its mission, fulfill it, or betray it," we at the Freedwomen's Bureau wonder whether the hasty rush to the post-black promised land is fulfillment or betrayal. Undoubtedly your friends feel a need to keep current, but Uplifting the Race is not a matter to be handled as blithely as upgrading to the latest Mac operating system. Being the daughters of our mothers means that we have many options and fewer restrictions on our dreams than of any moment previous. The question remains, as ever, what we do with those options and dreams.

Lest you fear being left behind when the post-black rapture comes, I ask you to take moment and consider those who are truly "left behind." More than likely, those among our people whose lives are still determined by inconvenient realities like mass incarceration and high infant / maternal mortality, just to name two, are not wondering at all about the fuss.

Dear Sojouner,
Every time I turn around I'm bombarded by another controversy aimed at our sistren. From the abortion billboards to the "single black woman" alarmist media stories, and "slave earrings" I'm on the verge of yanking out my double-strand twists! And now that Queen B and Hov are expecting, even other women are finger-wagging about "doing it the right way". What's a freedwoman to do?

Yours in struggle,
Dissed Sis

Dear Dissed,
We feel your pain. It's true, public scrutiny of our most intimate desires, choices and challenges seems to be at an all time high. (Which is impressive, when you consider the sexual terrorism of slavery, forced sterilization, mass media objectification and other greatest hits of the patriarchy.) In the face of what seems like an ongoing assault, what form should our resistance take? Direct action is always important, and petitions, protests, telephone campaigns and the creation of counteractive media have been important in all of the controversies your mention. But how, in the the middle of all that resisting, do we keep our joy? Now, Sojouner is not Iyanla or Oprah. Here at the Bureau, we've always believed that the greatest resistance is to be exactly ourselves, for as freedwoman Audre Lorde taught us, "If I didn't define myself for myself, I would be crunched into other people's fantasies for me and eaten alive." What's more, by being your free, unregimented and unbossed self all the time and in public, you're setting an example for little freedwomen who are coming up. Let your example be larger than any billboard.

Dear Sojouner,
I'm caught between a rock and a hard place. I travel frequently and have natural hair. If I take an early flight, I often wear some kind of head wrap, but that always causes a security nuisance as the guards insistence on groping my wrap. Now with the recent incident where the sister had her fro searched wearing my hair unleashed is not an option either. Am I supposed to devise a security friendly hair style, cornrows perhaps? I don't want to cut my hair; been feeling so inspired ever since the Guinness record for largest Afro ever was set.

Signed,
Tressed Out Traveler

Dear Tressed,
It's unfortunate that the indignities of modern travel lay this particular burden upon sisters who, for reasons of convenience or belief, cover their heads and to others

who set their locks flowing. My advice to you is simple: tell the next guard who wants to pat your head or caress your 'fro to use all the powers that their high-falutin' technology bestows upon them by waving one of those metal detecting magic wands around your halo.

CAMPAIGN

Speaking of hair (and aren't we always speaking of hair?), this marks a perfect occasion to announce the latest campaign of The Freedwomen's Bureau. Here are The Bureau, we've been playing close attention to the profusion of blogs, YouTube videos, message boards, Meet Up groups, etc all enthusiastically devoted to the cause of natural hair. Ever since the days of Madame Walker, our crowning glory has been a path to self-determination; the beauty salon has always been a well around which we gather for community and to quench our souls. We understand the need for celebration and affirmation in the face of undermining beauty standards. And while The Bureau believes in the proliferation of knowledge and supports the sharing of resources it appears to us that an inordinate amount of energy is going into hair care. Dare we make it plain? Is natural hair, once a symbol of unity, now merely the playground of self-regarding vanity? Are we becoming bound to something that was supposed to make us free? How are we going to fight the power if we must spend at least one full day a week on our Ayurvedic-coconut cream & castor oil deep condish- herbal steam treatments and then blog about it? It has us asking that ever-urgent question for these politically murky times, WWADD? (What Would Angela Davis Do?) And, as we must ask ourselves whenever the chains of conformity make their rattling approach, WWBDD? (What Would Betty Davis Do?). As their legacies teach us, these phenomenal women weren't just doing

their phenomenal hair.

With that in mind, The Freedwomen's Bureau hereby launches

the WHAT ARE YOU DOING BESIDES YOUR HAIR? campaign

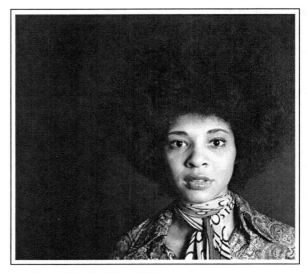

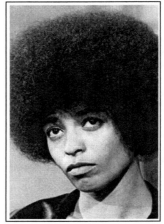

We are certain that, in addition to doing your hair, our readers are doing other incredible things for the cause of liberation. Each month "From the Desk of the Freedwomen's Bureau" will feature a reader who not only has fabulous, well-conditioned hair, but who is also taking inspiring action in her community. Kindly submit your photos and a recent curriculum vitae to our editorial offices or to *bureau@freedwomens.us*

As always, we leave you with the immortal imperatives to "lift as you rise," "speak truth to power" and "shake what your mama gave you." We who believe in freedom truly cannot rest.

BEAUTY

Brown American, Vol 1. No. 1, (April 1936)

THE desire for Beauty was given birth in the Garden of Eden, when Eve discovered her reflection in a placid, still-surfaced pool. Thus, vanity was born, that keen feminine yearning to improve upon nature, to capture and to maintain beauty, in terms of retaining love.

The modern girl has accepted the beauty parlor as a definite part of her set-up and, with an air of nonchalance, receives her weekly manicure and finger-wave. And, in this carefree manner chooses from among a thousand and one beauty aids and never pauses to consider how fortunate she is in having the accessories to enhance beauty so close to her and her touch.

In the past lovely ladies were not fortunate due to rarity and the costly price which confined its limitations to the very wealthy.

The beauty of Cleopatra ruled the Land of the Nile, rather than her brain-matter, spending a large portion of the day in the hands of tirewomen, whose function preserved the charm and loveliness of their mistress. Her gorgeous auburn hair was artistically tinted with henna. The skin was made familiar with countless oils and unguents. Her eyes of expressive size were carefully outlined with mascara and cream. So, fame and fortune awaited the dusky-skinned chemist who would present a new perfume that would rob the lotus of its fragrance.

Helen of Troy, for whom a city was razed to ashes, scoffed at the idea of over-use of cosmetics, as did most of the Spartan sisters, but the pulchritude of her tresses, and the symmetry of her form, bespoke hours of rigid adherence to beauty principles.

Semiramis of Babylon, lovely as her name, entrusted her beauty to the hands of pigmented slave masseurs trained from childhood in their art.

The fetish of loveliness gave rise with the Roman Ladies. Poppaea, wife of Nero, was acclaimed the most beautiful and ambitious of Roman matrons. She bathed daily in milk, which was intended to keep the skin free of wrinkles and smooth and soft to touch. She personally invented numerous powders, paints, salves, creams and mascaras. Most of her time was spent in the art of loveliness.

In the year of 64 B.C., Sabina, of Rome, displayed the first permanent wave on record. Her straight, luxuriant hair was rolled carefully on slender pieces of wood, packed in clay and baked daily in the sun for a period of three weeks. It was let down, washed and treated with shellac to preserve the waves. One hundred and fifty slaves and beauticians were required to accomplish the art of making one woman's hair lie close to her brow in soft, caressing curls. The modern business girl who rushes over to her favorite beauty parlor, after work, and emerges with a permanent wave in time for her theater engagement would find Sabina's recipe for lovely tresses a bit wearing.

Having your face lifted is not very new. Plastic Surgery of a sort was not unknown to the Roman matron who saw her beauty fading with the years. Dentifrices, cheekpads, wrinkle-removers and even false teeth adorned more than one tottering Roman ruin who had fond memories of a lovelier girlhood.

The great grand-daddy of our present vanity case has been found in Assyrian and Egyptian ruins. Rouge pots have been known since the dawn of civilization. Patient Job's youngest sister was named—oddly, "Keren Happuch"—which means, no more or less than, "Rouge Jar."

Madame Du Barry, favorite of Louis XV, applied six different kinds of cold creams to her face, and jealously kept her formula for rouge in secret. She lavishly cared for her eyebrows and lashes, tinting her finger nails a rosy hue and penciling blue the veins of the face.

Her predecessor, Madame Pompadour, was ostentatious in elegance for her coiffure, and set a style of hairdressing which bears her name to this day.

Catherine of Russia, though bald as an eagle, kept her wigmaker in confinement to the day of his death lest he should betray her secret. Mary of Scotland, beheaded in her early forties, went to her death proudly wearing her finest wig.

Women have guarded beauty as their source of power from the earliest days, but never before has it been so simple, so easy for women to be beautiful. Modern Milady spends tremendous sums daily in her conquest to improve upon nature and cheerfully pays the bill without whimpering.

Beauty has become the fifth largest industry in the United States, outranked only by the automobile industry, steel manufacturing and food. Ten years ago it ranked fourteenth. Beauty shops have increased with the years and new cosmetics reach the counter daily.

Hundreds spend their lifetimes over Bunsen burners and with test tubes experimenting for new fragrance that will make Milady more alluring than ever. And with it all the divorce statistics continue to mount in numbers.

SARA SPENCER WASHINGTON.

A HINT TO OUR WOMEN.

A HINT TO OUR WOMEN.

MRS. MATTIE HURD RUTLEDGE.

Colored American, Vol. 1 No. 2 (June 1902)

Our race is still progressing, financially and educationally. Some devote most of their time to reading, and this is

The rich of our race are taking care of themselves, so we must look out for ourselves. To do this, we must aggregate

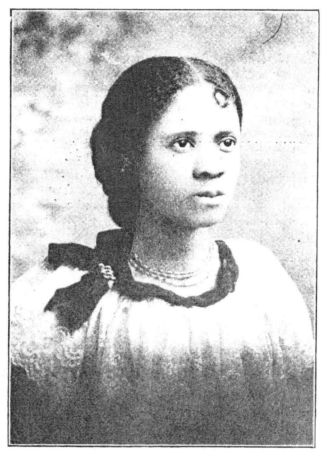

MISS ALICE NUGENT, LOUISVILLE, KY.
(See page 136.)

very essential to elevation, while others have duties that will not allow them to spend their time in this way, but as this is the first step upon the ladder of success, I advise each of you to begin utilizing your time daily, by spending at least a half hour in the reading of some good book.

We lose too much time, just throw it away. Napoleon attributed his success to taking care of each moment. Just think of that, each moment, and think of the idle hours we have.

and use our spare means to the best advantage.

We are not able to establish libraries, although there may be some that I don't know of, we are not able to establish schools, colleges, and kindergartens as we need for our people.

We have not the means to erect hospitals, homes enough for our aged, homes enough for our orphans, schools of industry for our youth, but the little we can do, we are not doing, we can unite ourselves together by making a

A

We must begin to look out for our people. The opposite race are devoting much of their time to the protection of birds, etc. This I don't say is unnecessary, but they are fighting against social equality. I think Mrs. Josephine Ruffin right in applying for admission to the convention of woman's clubs at Los Angeles, Cal.

We have some brainy women. These I claim, are as good as the white, and why not let them enter to show the good their race is doing, so that to many of our citizens of this great country, our advancement should be known. A Christian, civilized race, claiming to keep the commandments of God, will not do justice to such a meek, humble race as the Negro race. Do they love their neighbor as themselves? Let them note the superiority they claim to possess, that they have shown in California. Let us not look at this on the wrong side, but let it be a cannot do so merely by talking, but we must make a sacrifice, and show by the help of God, we love our neighbor as ourselves.

In the past years our foreparents have given the opposite race labor, to-day they do not need our assistance; all the riches lie in their hands; let us begin working and striving for each other. "Love lightens labor." By uniting we may help each other and also our youth.

We pray for more industries among our people, more intelligence and prosperity, then in the face of difficulties we can succeed. Let us work with energy for these golden powers, then social equality will attend to itself.

Plant yourself, if you want to grow.

Preserve your individuality, also, by maintaining your privacy, and like an ancient philosopher who lived in a tub, let not even a king obscure your sunshine.

Purgation

By GWENDOLYN BENNETT

YOU LIVED
and your body
Clothed the flames of earth.

Now that the fires have burned away
And left your body cold,
I tremble as I stand
Before the chiseled marble
Of your dust-freed soul.

Troubled Women

By LANGSTON HUGHES

She stands
In the quiet darkness,
This troubled woman,
Bowed by
Weariness and pain,
Like an
Autumn flower
In the frozen rain.
Like a
Wind-blown autumn flower
That never lifts its head
Again.

SOME
HEADLINES

The Crisis Vol. 3 No. 1 (November 1911)

[The Crown is a paper published in Newark, N. J., "in the interests of practical religion." Its editor interprets this mission to include attacking race prejudice on every occasion, and we have before this quoted his burning and witty editorials. He recently published an extremely clever and suggestive essay on the psychology of newspaper headlines. which we reproduce almost in full.]

The daily papers always call attention to the fact that a crime was committed by a Negro. This is quite right. It is a matter of social interest to know how crime is distributed between whites and blacks, as also between native born and foreign born. It is in the way of calling attention to the color of the crime that the wrong lies.

The newspaper method of indicating this is to say that the criminal is a Negro, if he is, but if he is a white man to say nothing about his color, leaving that to be inferred. This course is adopted because there are so many more whites than Negroes, and hence it is necessary to print the word "Negro" or "colored" much less often than it would the word "white." The rule would be a good one, if people would only apply it rightly. But they do not, and they cannot be taught to do it.

Here is how it works out: The reader sees after the name of a lawbreaker the word "Negro" or "colored." He sees this word day after day, and almost always associated with crime. He never sees the word "white" in this relation. And thus little by little, without his being aware of it, the impression is made on his mind that the Negro is a great criminal. The white murderer is merged with the criminal class, whereas the Negro murderer is identified, not with the nondescript criminal class, but with the Negro race. Thus the Negro race is made to bear the odium of its crime, which is just; but the white race is relieved of the odium of its crime, which is unjust.

The disadvantage of the Negro is that in apportioning crime between whites and blacks only an act of the senses, namely, of the sight, is required by the reader of the newspaper to connect the Negro with crime; whereas in the case of the white a mental act is needed. Advertisers well understand the value of a repeated appeal to the eye, and that is why, month after month, they repeat the catchy phrase or picture. The mind insensibly becomes habituated to it. So, too, when newspapers day after day repeat Negro and crime, Negro and burglar, Negro and murder, Negro and assault, the mind of the reader automatically comes to regard the Negro as spending his time in committing crime.

Take it in another field. Suppose that the newspapers. thought it important to indicate the division of crime between Protestants and Catholics (never mind the Jews just now). And suppose that because the Catholics are so much fewer the papers should do as they do with the Negro, that is, indicate the word Catholic, but leave the word Protestant to be inferred. Would any papers dare do this? And why not? Because the Catholics would not stand it; and they would be right. No matter what the facts, people would come to think of Catholics as criminal above others. "The papers," they would say, "are full of crimes by Catholics." If they were reminded that their own Catholic friends and acquaintances were not criminals— why, those are exceptions—the rule still holds that Catholics are criminals.

Now what is the remedy? For one thing, it can be assumed that newspapers will continue to apportion crime between white and black people. But let it be done fairly. Let us see how this suggestion would work out. I take this morning's paper, and scan the items of crimes. As it happens, on this July 5, there is not a single offence imputed to a Negro. Evidently they spent Independence Day becomingly. Every crime reported on that day was committed by a white man. Yet the reader would never think of this significant fact, simply because his attention is not called to it. But suppose it were. Suppose that after the name of each person accused of wrongdoing in the newspaper this morning the word "white" should follow, as the word "Negro" or "colored" would. Here is how the record would look:

JANITOR (WHITE) TAKES LIFE OF TENANT.

YOUTH (WHITE) WANTONLY SLAYS BOY.

MAN (WHITE) PUTS FATAL BULLET INTO RIVAL WHO DEFENDED GIRL'S NAME.

SIX ON STOOP SHOT BY MAN (WHITE) ACROSS STREET.

TWO BURGLARS (WHITE) HIT IN FURIOUS BATTLE WITH POLICE.

ATTACKED BY ROUGHS (WHITE)
A VISITOR (WHITE) FROM OUT
OF TOWN MORTALLY WOUNDS
ONLOOKER.
GOVERNMENT AFTER SMUG-
GLERS (WHITE).
OFFERS TO EXPOSE BAND OF
ROBBERS (WHITE) IF
RELEASED.
HIGH JINKS BY HUSBAND
(WHITE) ALLEGED BY
WIFE.
KILLED FRIEND WHO SPLASHED
HIM (WHITE).
FIND TRAIL OF TWO OF WEI-
GEL'S MURDERERS (WHITE).
YEGGS (WHITE) BLOW SAFE IN
BALDWIN.
SHOOTS DETECTIVE FOUR TIMES
AND IS SHOT TWICE HIM-
SELF (WHITE).
TWO BURGLARS (WHITE) ARE
SHOT IN BATTLE WITH
POLICEMAN.

Now the comment of the reader on these news items, so set forth, would be: "How good the colored people were yesterday. The whites seem to have been making all the trouble." The Negroes would receive credit for their clean record, as they should. As it is, nobody gives them a thought; and nobody gives them a thought except when they go wrong; and then all are blamed for the sin of a few.

The Next Day.—This morning's paper has no Negro crime reported either! This is interesting. Now, as for yesterday's criminal chronicle, so for to-day's let us put it in plain words that these supposed criminals were white, as it would be plainly set forth that they were black:

SWINDLE CHARGED AGAINST
TWO MEN (WHITE) OF GOOD
FAMILY.
ECHOES OF GRAFT (BY WHITE
MEN) FOLLOW DISCHARGE
OF CITY FIREWORKS.
BURGLAR (WHITE) SON OF BANK-
ER ADMITS LOOTING EIGHT-
EEN HOMES.
FASHIONABLE DAKOTA SCENE
OF FIERCE FIGHT (BY
WHITES).
SEES SON (WHITE) JAILED FOR
LIFE.
REICHMANN (WHITE) IS OUT ON
BAIL.
WOMAN LANDS THIEF (WHITE)
AFTER A HARD FIGHT.
EX-POLICEMAN (WHITE) CAUGHT
PASSING "PHONY" CHECK.

BLACK-HAND LETTER SENT TO
OIL MAGNATE BY DETEC-
TIVE (WHITE).
HIS PICTURE HER WEAPON
(BOTH WHITE).

Next Day.—Again the paper has no item of crime by a Negro. What is the matter? Have they struck? Not, at least, to hurt anybody.

Here is the police record for the day:
MILLIONAIRE HOTEL PROPRIE-
TOR AND THE TWO WOMEN
CONFRONT EACH OTHER
(ALL WHITE).
MAN (WHITE) FINED FOR KISS-
ING GIRL.
ROBBERS (WHITE) BIND AND
GAG A WOMAN.
GRAFT IN STATE PRISONS (BY
WHITES).
MEAT PACKERS (WHITE) AR-
RAIGNED.
POLICE CAPTAIN (WHITE) LIES
AND IS DEGRADED.
HIGH-BORN THIEF (WHITE) HAS
TRUNK FULL OF LOVE
LETTERS.
HUSBANDS (WHITE) DOING TIME
APPEAL TO SPOUSES.
WILL TAKE BACK RUNAWAY
WIFE (WHITE).

The Next Day.—And still no Negro wrongdoing in the paper! This virtue is becoming monotonous. If it were not for the whites, the papers would not be worth reading. Here is yesterday's white list:

GEM SMUGGLING (WHITE).
MURDER AND SUICIDE IN A BAL-
LOON (BOTH WHITE).
SUES FOR DIVORCE (BOTH
WHITE).
BOARDER (WHITE) ARRESTED AS
THIEF.
WITNESS ABDUCTED AND MADE
DRUNK (ALL CONCERNED
WHITE).
POLICE CLUBBER (WHITE) TO
PRISON.
BURGLAR'S (WHITE) CLEAN
SWEEP.
INVESTMENT FAKERS (WHITE).
AUTOIST (WHITE) BREAKS A
MAN'S LEG.
POLICEMAN (WHITE) ACCUSED
OF EXTORTION.
NEW DIVORCE COMPLAINT
(BOTH PARTIES WHITE).
FATHER (WHITE) DESERTS
MOTHERLESS CHILDREN.
TOO FOND OF "NIECES" (ALL
CONCERNED WHITE).

A

LETTERS

FROM WHITE FOLK.

To begin, I am a white woman, and have loved the colored race from infancy. I happened to pick up a copy of THE CRISIS and was truly shocked at its tendency; so far as I can see your book only creates discontent among your people.

If you had the least idea of the harm you are doing you would stop it. Social equality you will never have, but there is chance to improve conditions of a race that can be magnificent without social equality.

(Signed) E. J. H.

Many thanks, my dear CRISIS, for your prophetic monthly. It started our way as a Christmas present a few years ago. The bitterness of so many of my people toward the problem they themselves brought to this country fills me with sadness; but Love is Life—there is no other life. It must win since God is. God, who sees beneath all non-essentials, and the deeper the experience passed through the higher the heights attained. Oh, I sorrow with you, almost I believe as one of you, in the insults my race heaps upon you. But steady, brother mine, nothing can hurt us save our own wrongdoing. There is no death. Covered in darkness for a day, it will be light for you *forever*.

God bless you and keep you on the Heights.
Most gratefully and fraternally,
(Signed) VICTOR LYNCH GREENWOOD.

LINCOLN UNIVERSITY, March 8, 1913.

Please discontinue my subscription to THE CRISIS. GEORGE JOHNSON,
Dean.

FROM COLORED FOLK.

DEAR SIR:

I wish to say to you that there is much truck grown in this section of North Carolina by the colored people, and the white man has been shipping it for us to the whites North, etc. Now we are becoming restless about it somewhat and want to know if there are any colored commission merchants in New York. If so, will you kindly put us in touch with them? If not any there, can't some one come to the front and be one for a few months in the year in order that we may ship at least some of our truck to them. I mean some good man who will deal fair with us and give us a living price for it. There are many, many thousands of crates that are shipped from this point every year, such as peas, beans, cabbage, etc., and many thousands of dollars are made by the commission merchants who handle it, and it seems to me that there ought to be in New York, Philadelphia and Boston at least one colored firm of commission merchants who would or could handle a portion of the Southern colored produce. There is money in it for the right man. We will begin to ship about the 18th or 20th of April, and if, as I have said, you can put me in touch with someone whom you think would like to take up the matter with me, I will be very glad to hear from them.

Thanking you in advance and anxiously waiting to hear from you, I am,

Yours respectfully,

I have found truth and the bright side of the Negro in THE CRISIS, from the first time of its publication.

J. W. FISHER,
Wallingford, Conn.

CRISIS bearing fruit here; one of most eagerly sought for of our magazines in college library. HARRY H. JONES,
Oberlin, O.

I

MINUTE MEN
525,600
minutes a year!

1,000,000 volunteers in 3,000 communities . . . modern Minute Men on call for any community service from fighting a flood to building new teeter-totters for a children's playground . . . Chamber of Commerce members working, planning, dreaming 365 days a year to make their communities happier, healthier, wealthier places in which to live.

Working and fighting now, as such Americans have worked and fought since Colonial days, for the fair, free functioning of American life and business.

The times, alone, have changed —the spirit marches on!

Community progress still has its advance guard.

Business pioneers are still out in front, pushing back the frontiers of trade and industry, opening new fields of opportunity, blazing paths for others to follow.

If you are interested in a special pamphlet on the subject of teamwork in business through Chambers of Commerce, write: NATION'S BUSINESS, *U. S. Chamber Bldg., Washington, D. C. No obligation.*

This advertisement is published by
NATION'S BUSINESS

—a magazine devoted to interpreting business to itself, and bringing about a better understanding of the intricate relations of government and business. The facts published here are indicative of its spirit and contents. Write for sample copy to NATION'S BUSINESS, WASHINGTON, D. C.

I

I

I

ST James RECIEVED

JESUS BY MOSES

I AND GOD SPAKE THESE WORDS SA

II ING I AM THE LORD THY GOD WH

III HAVE BROUGHT THEE OUT OF TH

IV LAND OF EGYPT OUT OF THE

V HOUSE OF BONDAGE THOU "SHALT

VI HAVE NO OTHER GODS BEFORE

James Hampton (1909-1964), excerpt from "P" Papers, n.d.

The Reader

For more information, please visit: http://www.newmuseum.org.

ISBN: 978-0-9833815-7-0

This publication was created as a part of the exhibition "Museum as Hub: Steffani Jemison and Jamal Cyrus: Alpha's Bet Is Not Over Yet!" at The New Museum of Contemporary Art.

Museum as Hub is made possible by the New York City Department of Cultural Affairs and the New York State Council on the Arts. Endowment support is provided by the Rockefeller Brothers Fund, the Skadden, Arps Education Programs Fund, and the William Randolph Hearst Endowed Fund for Education Programs at the New Museum. Education programs are made possible by a generous grant from Goldman Sachs Gives at the recommendation of David and Hermine Heller.

Editor: Steffani Jemison
Designer: Nikki Pressley
Cover image: Adebukola Bodunrin and Jamal Cyrus

Contributors: Jamal Cyrus, Egie Ighile, Mitchell Jackson, Steffani Jemison, Ryan Inouye, Sharifa Rhodes-Pitts/ The Freedwoman's Bureau, Ethan Swan, Greg Tate

Special thanks to: Shannon Bowser, Joshua Edwards, Quincy Flowers, Eungie Joo, Victoria Manning, Leire San Martin

CPSIA information can be obtained at www.ICGtesting.com
Printed in the USA
BVOW022341201011

274144BV00003B/1/P